# Portrait of a Primitive

# Portrait of a Primitive

## THE ART OF HENRI ROUSSEAU

Ronald Alley

A Dutton Paperback

E. P. Dutton · New York

Phaidon Press Limited, Littlegate House,
St Ebbe's Street, Oxford

First published 1978
Published in the U.S.A. by E. P. Dutton, New York
© 1978 Phaidon Press Limited
All rights reserved

ISBN 0 7148 1825 9 (cased)
ISBN 0 7148 1908 5 (paperback)

Library of Congress Catalog Card Number: 78-55003

Printed in Great Britain by Waterlow (Dunstable) Ltd

Note: The paintings formerly in the collection of
Pablo Picasso (Plates 24, 41 42, 50) are now the
property of the Louvre.

# List of Plates

# Select Bibliography

Arsène Alexandre, 'La Vie et l'Oeuvre d'Henri Rousseau, Peintre et ancien Employé de l'Octroi' in *Comoedia*, 19 March 1910

Wilhelm Uhde, *Henri Rousseau* (Paris 1911)

*Les Soirées de Paris*, No. 20, 15 January 1914 (bears the incorrect date 1913)

Roch Grey, *Henri Rousseau* (Rome 1922)

André Salmon, *Henri Rousseau dit le Douanier* (Paris 1927)

Adolphe Basler, *Henri Rousseau: sa Vie, son Oeuvre* (Paris 1927)

Ingeborg Eichmann, 'Five Sketches by Henri Rousseau' in *Burlington Magazine*, LXXII, 1938, pp. 302–7

Max Weber, 'Rousseau as I knew Him' in *Art News*, XLI, 15–28 February 1942, p.17

Daniel Catton Rich, *Henri Rousseau* (New York 1946)

'Henri Rousseau: Documents retrouvés' in *Labyrinthe*, No. 21, July–August 1946, pp. 3–5

Charles Chassé, *Dans les Coulisses de la Gloire: D'Ubu Roi au Douanier Rousseau* (Paris 1947)

Jeanne Bernard, 'La Petite Fille d'Henri Rousseau raconte la Vie de son Grand-Père' in *Arts*, No. 136, 17 October 1947, pp.1 and 6

Yves Le Diberder, 'Henri Rousseau s'inspirait-il de Photos et de Gravures?' in *Beaux-Arts*, 26 December 1947, p. 1

Wilhelm Uhde, *Five Primitive Masters* (New York 1949)

Ardengo Soffici, *Trenta Artisti Moderni Italiani e Stranieri* (Florence 1950)

'Images inédites du Douanier Rousseau' in *Les Lettres Françaises*, 1 August 1952, p. 8

Robert Delaunay, 'Mon Ami Henri Rousseau' in *Les Lettres Françaises*, 7 August 1952, pp. 1 and 9; 21 August 1952, p. 7; 28 August 1952, pp. 1 and 7; 4 September 1952, p.8

Maurice Garçon, *Le Douanier Rousseau, Accusé naïf* (Paris 1953)

Roger Shattuck, *The Banquet Years* (London 1959)

Yann Le Pichon, 'Les Sources de Rousseau révélées' in *Arts*, No. 809, 15–21 February 1961, p. 11

Henry Certigny, *La Vérité sur le Douanier Rousseau* (Paris 1961)

Marie-Thérèse de Forges, 'Une Source du Douanier Rousseau' in *Art de France*, IV, 1964, pp. 360–1

Henry Certigny, *La Vérité sur le Douanier Rousseau (Addenda No. 1)* (Paris 1966)

Dora Vallier, *Tout l'Oeuvre peint de Henri Rousseau* (Paris 1970)

Anatole Jakovsky, 'Le Douanier Rousseau savait-il peindre?' in *Médecine de France*, No. 218, 1971, pp. 25–40

Henry Certigny, *La Vérité sur le Douanier Rousseau (Addenda No. 2)* (Lausanne-Paris 1971)

Guillaume Apollinaire, *Apollinaire on Art: Essays and Reviews 1902–1918* (London 1972)

Henry Certigny, *Le Douanier Rousseau et Frumence Biche* (Lausanne-Paris 1973)

The most valuable first-hand accounts are by Alexandre, Apollinaire, Basler, Robert Delaunay, Roch Grey, Salmon, Soffici, Uhde and Weber. Henry Certigny has done the most fundamental recent research. Dora Vallier's *Tout l'Oeuvre peint . . .* is the only *catalogue raisonné*, but some of its dates and attributions are open to dispute.

# Portrait of a Primitive

The work of Henri Rousseau, 'Le Douanier', presents the art historian with problems which are unfamiliar. For Rousseau was the first artist to attract attention as a so-called 'modern primitive'. He is grouped with Bauchant, Bombois, Vivin, Séraphine and various others as 'naïve painters', 'popular painters of reality' or 'Sunday painters'. Although none of these titles is wholly satisfactory—for Rousseau was neither as naïve as has sometimes been suggested nor did he work only on Sundays—it is clear that we are dealing with a new category of artist who does not belong neatly to any tradition.

All these painters were self-taught. They came to painting comparatively late in life and never attained the technical standards which the academies required. They had very little knowledge of anatomy or linear perspective and it would have been quite beyond them to make a 'correct' drawing of the human figure. They never submitted to the discipline of working closely from nature, but instead contented themselves with approximations. As a result their work has an affinity with the art of children.

Another characteristic of them is that they all, or almost all, came of a working-class or lower-middle-class background completely unsophisticated as regards the visual arts. Rousseau's father was a dealer in tin-ware and he had himself worked for some years as a minor inspector at toll stations on the outskirts of Paris. Bauchant was a market gardener, Séraphine a housemaid and Bombois a strong man in a circus. They all began to paint in their spare time through a genuine urge for self-expression, and it is partly this that gives the best of their work an authentic poetry.

The basic facts about Rousseau's early life are soon told. He was born on 21 May 1844 in Laval (Mayenne), where his father owned a tin-ware shop. His maternal great-grandfather, on the other hand, was a colonel in the armies of the Revolution and the Empire, with a distinguished record for valour, while his maternal grandfather was an army captain who died of fever during the French campaign in Algeria. When Rousseau was still a boy, his father began to run into serious financial difficulties, mainly through his imprudent purchase of several properties with the aid of loans which proved to be quite beyond his means. In 1852 he was obliged to close his shop and liquidate his stock, and in 1852-3 his properties were seized by court order and sold by auction for the benefit of his creditors. Rousseau's father and mother moved a few months later to Couptrain, about thirty-five miles away, where they ran a tobacconist's shop, but Rousseau apparently remained at Laval with relatives until he finished his schooling in the summer of 1860. By the summer of 1863 he was in the employ of a

solicitor at Angers, where his family had settled, but soon afterwards became involved with two of his friends in pilfering small sums of money and a few postage stamps—in his case to a total value of 20 francs. In the hope of avoiding trouble he volunteered for seven years' service in the army, but this did not save him from having to serve a month's imprisonment in February-March 1864 for thefts and abuse of confidence.

This was the period of Napoleon III's ill-fated attempts to establish the Habsburg Archduke Maximilian on the throne of Mexico, attempts which ended eventually in the withdrawal of the French troops and the execution of Maximilian by a firing squad in 1867. It has often been suggested that Rousseau was sent to Mexico with the French troops at this time as a musician in a military band, and that this experience later inspired his jungle pictures, but the anecdotes told about Rousseau and his connections with Mexico are highly conflicting. Moreover his army records contain no reference to a posting in Mexico and facts like these were usually noted scrupulously in the register. Rousseau's father died in February 1868 and Rousseau obtained a discharge from the army in the following August, probably on compassionate grounds, in order to support his widowed mother.

On leaving the army he settled in Paris as assistant to a sheriff's officer. In 1869 he married his first wife, Clémence Boitard, who was to bear him no fewer than seven children, all but two of whom died in infancy, and who herself died of consumption in 1888 at the age of thirty-seven. After serving in the army again from July to September 1870, during the Franco-Prussian War, he obtained a post in December 1871 in the octroi service of Paris, apparently through the influence of one of his wife's relations, who was inspector of the octrois. At each of the city gates of Paris,

a small pavilion housed three or four officials who checked the contents of carriages entering the capital, because wine, grain, milk, salt and lamp-oil were subject to duty. The octroi official collected the tax and issued a paper called a *congé*. This was the occupation from which arose Rousseau's misleading nickname 'Le Douanier' (customs officer). He seems to have been a rather indifferent employee and never rose above the junior ranks of the service. According to some of the books about him he retired prematurely from the octroi service as early as 1884 in order to paint, but it has since been established that he continued with the octroi until as late as December 1893, when he retired at his own request on an annual pension of 1,019 francs. He had by then been exhibiting regularly at the Salon des Indépendants for eight years and his intention was to become a full-time professional artist. He supplemented his tiny pension by various jobs such as sign painter and sales inspector for the *Petit Parisien* for his part of Paris, and later by giving painting, violin and singing lessons.

Exactly when he first began to paint is uncertain. He told Arsène Alexandre in 1910: 'I was already forty-two years old when I touched a paint brush for the first time,' which would indicate that he started in 1886. On the other hand he obtained a permit in 1884 to copy in the Louvre, the Luxembourg and the museums of Versailles and Saint-Germain, and in May/June 1885 made his first appearance in an exhibition, with two pictures at the so-called Salon des Refusés, probably after his works had been rejected by the jury of the official Salon. The position is

1. Henri Rousseau. From a photograph given by the artist to Max Weber and inscribed: 'Gift to my friend Weber artist-painter. Paris 14/12. 1908. Henri Rousseau artist-painter.'

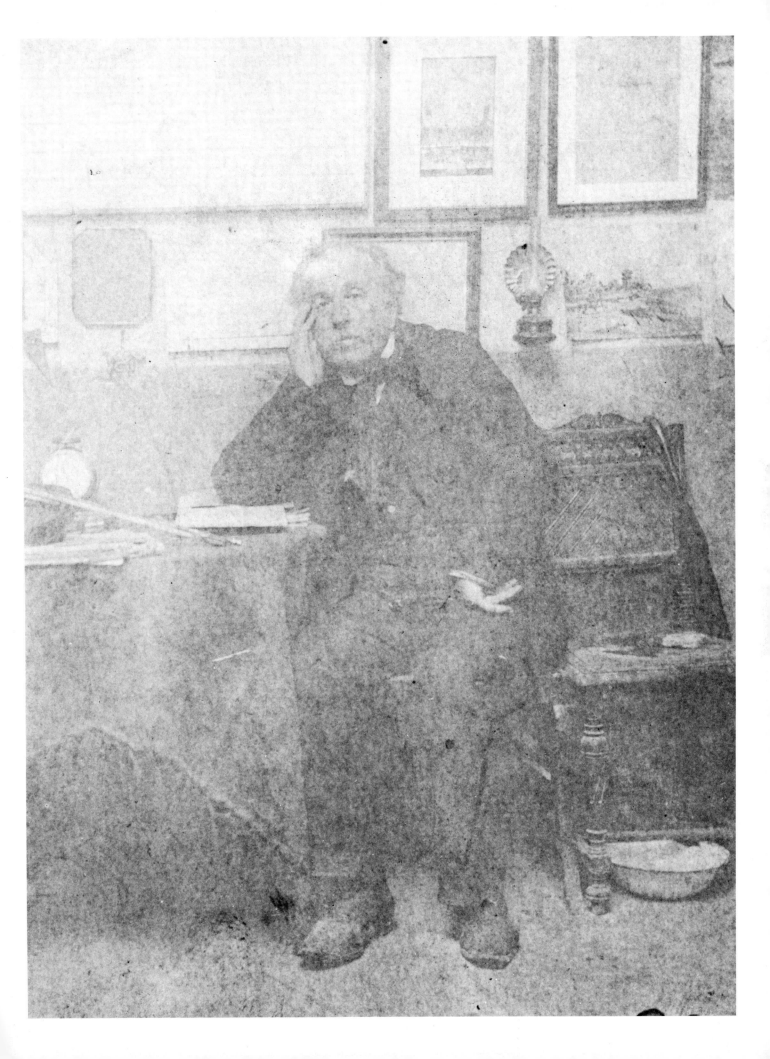

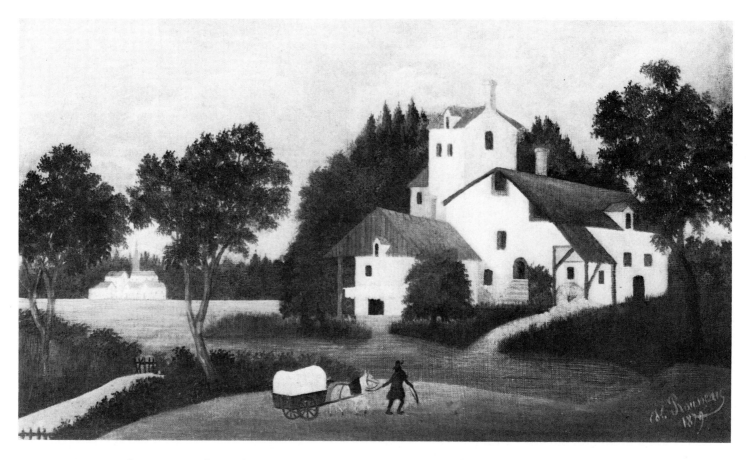

2. *Horse-drawn Cart in front of a Mill.* 1879. Canvas, 32.5 × 55.5 cm. (12¾ × 21⅞ in.) Gothenburg, Art Gallery

further complicated by the existence of several paintings which have dates even earlier than this, such as a landscape in the Gothenburg Art Gallery, which is signed and dated 1879 (Plate 2). Although very possibly the work of a beginner, and with a quaint little figure and horse and cart in the foreground, it shows an interest in pattern and simplification and even in a harmonious balance of verticals and horizontals provided by the building and the horizon line. In a second version of the same subject dated the following year, 1880, the composition is much more clarified. The elements are more or less the same, but they have been compressed sideways, with simplified forms, tonal contrasts of light and dark and stylized clouds floating in the sky. The

clear light, with an absence of atmospheric effects, is characteristic of all his works. If these pictures are indeed by him—and the Gothenburg painting was reproduced by Wilhelm Uhde as early as 1914—and the inscriptions are original, then Rousseau must have begun to paint several years earlier than he led Arsène Alexandre to believe. But in any case his interest in painting seems to have increased significantly in the years 1884-5, as he not only obtained a copyist's permit and exhibited for the first time, but went to the length of renting a studio in 1885 in the Impasse du Maine.

From 1886 Rousseau began to exhibit at the Salon des Indépendants and continued to exhibit there regularly every year except 1899

10

3. *The Family*. About 1885–6. Canvas, 46 × 55 cm. (18⅛ × 21⅝ in.)
Merion, Pa., Barnes Foundation (photograph © 1978 by the Barnes Foundation)

and 1900 until the end of his life. This Salon, which had been founded in 1884 by a group of young artists including Seurat, Signac and Redon, had the advantage that artists were allowed to exhibit without having to submit their work to a jury. Founded as an outlet for work which was not acceptable to the jury of the official Salon, it provided Rousseau with a most fortunate opportunity to show his pictures, which might otherwise never have emerged from obscurity.

Though the titles of his exhibits are listed in the catalogues, the majority of the paintings he showed at the Salon des Indépendants (as well as the two called *Italian Dance* and *Sunset* shown at the Salon des Refusés in 1885) seem to have been lost. However one of the four paintings which he exhibited at the Salon des Indépendants in 1886, *A Carnival Evening*, can be identified from descriptions in the reviews as a picture now in the Philadelphia Museum of Art (Plate 11). It must be said that it does not look like the work of someone who had only been painting for a few months, and in his very limited spare time. Leafless trees (carnivals normally take place in winter) form an intricate tracery against banks of cloud flushed by the glow of the setting sun. This landscape, with the moon above, shows Rousseau's ability to convey a mood of extraordinary poetic intensity. Only the two dark-skinned figures in their carnival costumes have a certain awkwardness in that their silhouettes seem to detach from the setting and their feet do not stand securely on the ground. They look as though they have been copied or even traced from some colour lithograph of the period.

One of the other pictures shown at the same Salon des Indépendants in 1886 under the title *Waiting* may be the painting now in the Kunsthaus, Zürich, which is usually known nowadays as *The Walk in the Forest* (Plate 10). A young woman, possibly Rousseau's first wife Clémence, turns abruptly, one hand raised. Although the luxuriant vegetation of the wood through which she walks has been suggested very successfully, Rousseau has not yet mastered the art of drawing trees. Those in the foreground have a few sprays of leaves attached to the ends of their branches, while beyond is a soft formless blur of autumnal colours. It can be compared with another early painting of a similar theme but with figures in period costume, *Rendezvous in the Forest* (Plate 4), in which there are many different types of leaf pattern. It is known that Rousseau was later in the habit of bringing leaves home to paint from, and he may have already begun to do this.

As he apparently had to work about seventy hours a week at the octroi, his time for painting must have been very limited and his early output until he retired was probably rather small. However he seems to have been allowed a certain amount of freedom to draw and perhaps even paint during working hours, for in 1907 he expressed his gratitude to his superiors in the octroi, who, he said, gave him less exacting duties so that he could pursue his artistic interests more easily. 'They have helped to give France our native land one of her sons, whose only aim is to make her still greater in foreign eyes.' According to his own estimate, his early work included about two hundred drawings in pen and pencil, of which only very few appear to have survived. The little pen and ink sketch of the Quai d'Auteuil dated 1885 may be one of those done in his spare moments during working hours (Plate 7). Some of his early landscape paintings also depict the areas on the outskirts of Paris, along the Seine or near the fortifications, where he worked, and in a landscape in the

4. *Rendezvous in the Forest*. About 1886–90. Canvas, 92 × 73 cm. (36¼ × 28¾ in.) Washington, National Gallery of Art

12

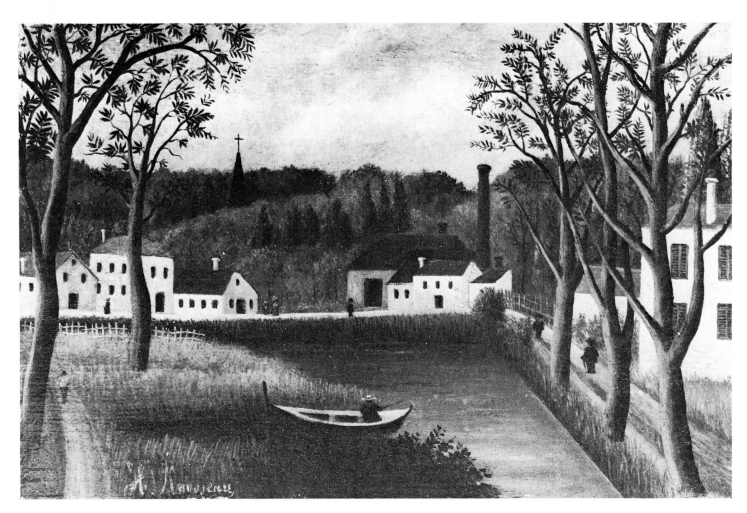

5. *Landscape with a Fisherman with a Rod.* About 1887–9.
Canvas, 23.5 × 37 cm. (9¼ × 14⅝ in.) Paris, E. Tappenbeck Collection (photograph Giraudon)

Courtauld Institute Galleries, London, we can even see one of the octroi posts (Plate 19).

Among his pictures exhibited at the Salon des Indépendants in 1890 was the famous self-portrait *Myself. Portrait-Landscape* (Plate 8), the earliest known example of the combination of portrait and landscape which he regarded as one of his specialities. Here Rousseau appears not as a humble beginner but as a professor of painting and a master painter, assured of his powers. And in fact, no matter how much ridicule he had to bear, he was well aware of his greatness as an artist. He wears in his buttonhole the badge of the *palmes académiques* (this must be a later addition, in or after 1904), and in his left hand he holds his palette inscribed with the names of his first and second wives Clémence and Joséphine. Though there is more space than in the earlier pictures, there is little relationship between the figure and its setting: Rousseau stands awkwardly on tiptoe and seems too big for the position he occupies, a disparity that is emphasized by the tiny figures of people walking along the quayside. (Rousseau tends at this stage to exaggerate differences in scale.) The setting is characteristically Parisian, with the Eiffel Tower—then a very new construction, only erected the previous year for the International Exhibition of 1889—in the background and a balloon sailing past in the sky. Colourful flags and the elongated sil-

14

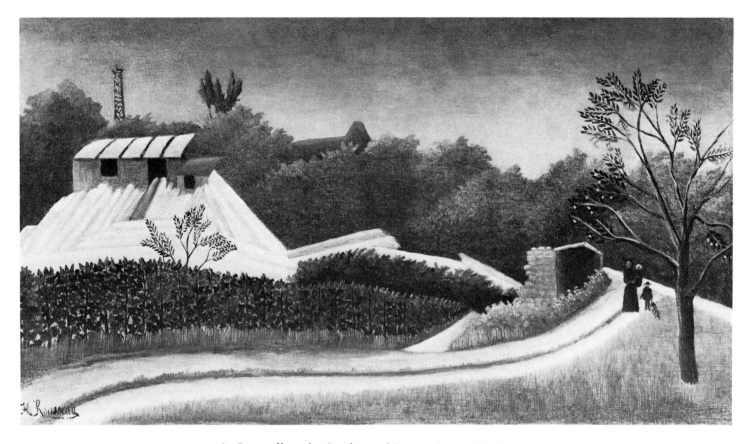

6. *Saw-mill on the Outskirts of Paris.* About 1892–3.
Canvas, 25.5 × 45.5 cm. (10 × 17⅞ in.) Art Institute of Chicago

houettes of the chimney-pots on the skyline add to the liveliness of the scene. A notable feature is Rousseau's extraordinary eye for tone and especially the richness of his blacks, which is said to have been praised by Gauguin. The air is clear and everything is sharply outlined, even the clouds. This is, of course, very different from the work of the Impressionists, which retains a sketch-like character and in which the contours are dissolved by light. And instead of the Impressionists' conspicuous brushwork, Rousseau aims at a high degree of finish.

From the following year, 1891, dates the first of his jungle pictures sometimes known as *The Storm in the Forest* but first exhibited at the Salon des Indépendants in 1891 under the title *Surprise!* (Plate 20). Lightning flashes and the jungle is swept by tempestuous wind and rain. Everything is thrown into convulsive movement; even the tiger slinks away in terror. Here we have one of the earliest demonstrations of Rousseau's imaginative powers, his sense of drama and mystery and of the strange forces of nature. Though the treatment is very individual, this kind of subject-matter —jungle, lions, tigers and hunters—was by no means uncommon at the period, for instance in the work of Delacroix and the painters of North Africa like Gérôme and Fromentin.

15

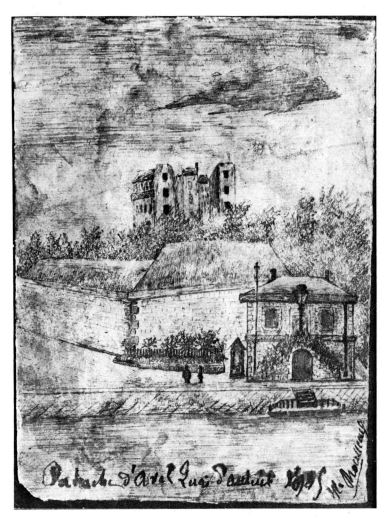

In 1892 Rousseau painted a picture to commemorate the centenary of the French Revolution, which he exhibited at the Salon des Indépendants the same year under the title *A Centenary of Independence*. (*The people dance around the two republics, those of 1792 and 1892, holding hands to the tune of 'Auprès de ma blonde qu'il fait bon, fait bon dormir'*) (Plate 9). Citizens wearing caps of Liberty dance together like Breugelesque peasants to the music of a band in the background. Two eighteenth-century aristocrats, or figures dressed as such, view the scene from the right. A gentle breeze blows all the banners in precisely the same direction—a careful but naïve touch of realism. There is a marked feeling of space, but the relationship of scale between the various groups remains awkward and uncertain. It is symptomatic of how seriously Rousseau took himself as an artist that he should decide to paint a large allegorical picture commemorating a public event; and he may also have done this, as in the case of some of his later compositions of a similar kind, in the vain hope that it would be purchased by the state. In the following year he made a further small version of this subject in a narrow horizontal format which he seems to have submitted unsuccessfully with another painting of the same size depicting the Pont de Grenelle and the Statue of Liberty in a competition for the decoration of the town hall of Bagnolet (Plate 12).

His first large work painted after his retirement from the octroi service—in fact his largest and most ambitious composition to date—seems to have been his picture of *War*, now in the Louvre in Paris (Plate 15), which was exhibited at the Salon des Indépendants in 1894. It is one of his few works where we know

7. *River Seine, Quai d'Auteuil.* 1885. Pen and Indian ink, 16 × 12.5 cm. (6¼ × 4⅞ in.) U.S.A. Private Collection (photograph Sotheby and Co.)

8. *Myself. Portrait-Landscape.* 1890. Canvas, 143 × 110.5 cm. (56¼ × 43⅜ in.) Prague, National Gallery

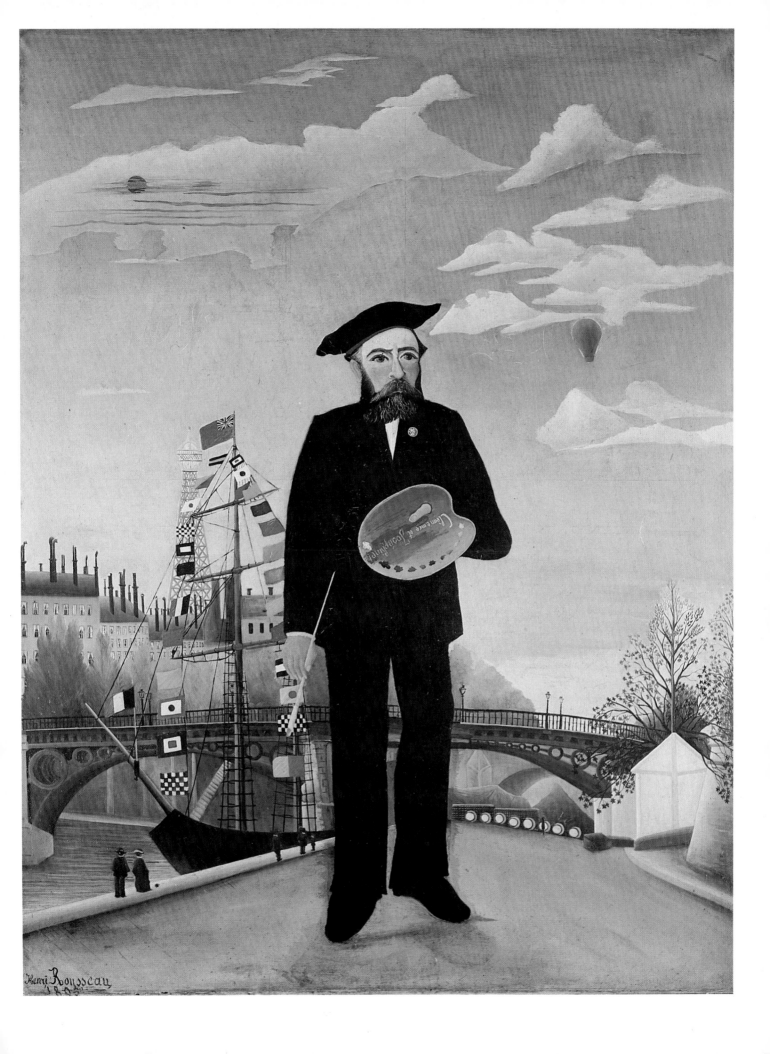

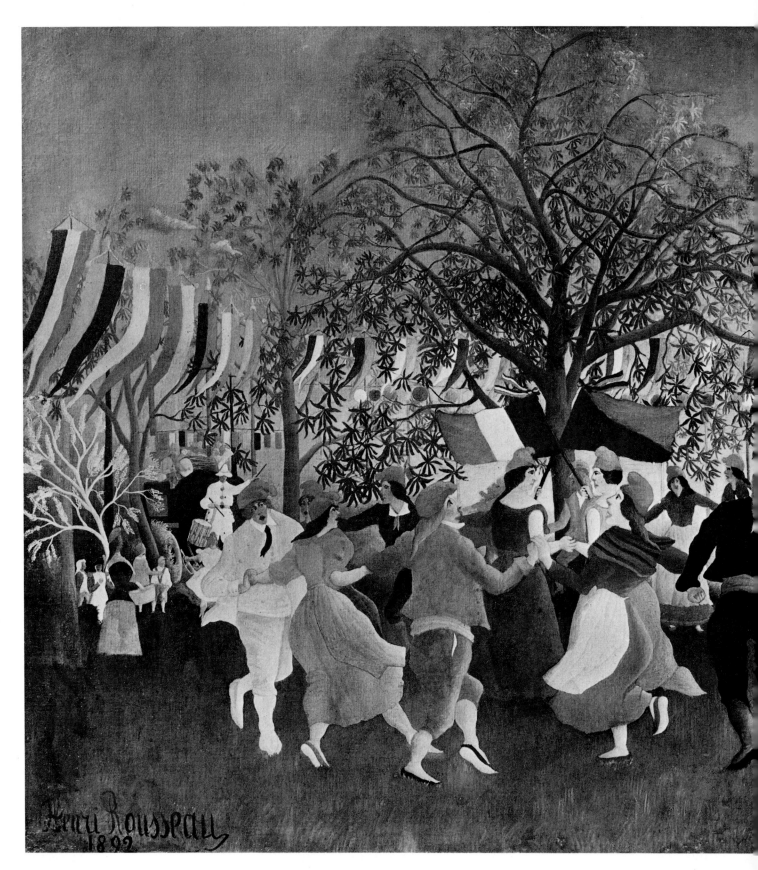

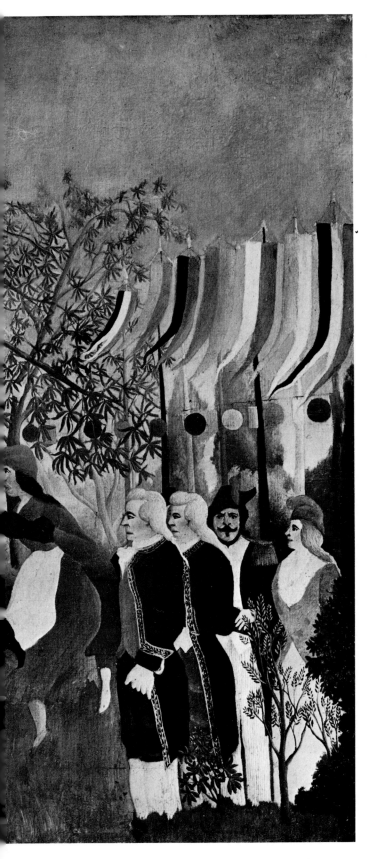

for certain that he took a specific image by someone else as his starting-point. The composition of *War* was based on an illustration for a novel *Le Tsar*, which was first published in *L'Egalité* on 6 October 1889 and then again three weeks later, on 27 October 1889, in *Le Courrier français*, and which depicts a sinister cloaked figure on a black horse galloping across a landscape strewn with corpses (Plate 13). Even the sentence that appears underneath this illustration, 'Everywhere the mysterious black horse passed, a disaster followed, a crime was committed,' is clearly related to Rousseau's own commentary on his picture published as part of the catalogue entry: 'She passes in terrifying fashion leaving everywhere despair, tears and ruin.' Although the main lines of the composition are very similar, Rousseau has changed the shadowy horseman into a demonic child with wild eyes and matted hair, who brandishes a burning torch in one hand and a sword in the other. She rides bareback on a black horse which charges across the countryside, its long tail streaming behind it. The clouds are flushed pale blood red, while the bodies of the dead and dying are being picked by crows. The drama has here taken on a note of savage expressionism: the horse, for all its anatomical oddness, has the furious momentum of a horse of the Apocalypse. Although Rousseau had been a soldier he hated war and said: 'If a king wants to wage war let a mother go to him and forbid it.' Whereas his early pictures were quiet and peaceful, this one is full of violent movement; and whereas the early works tend to be restrained in colour, with a palette centred round greens and browns, one sees signs here of a growing

9. *A Centenary of Independence.* (*The people dance around the two republics, those of* 1792 *and* 1892, *holding hands to the tune of 'Auprès de ma blonde qu'il fait bon, fait bon dormir'*). 1892. Canvas, 112 × 156.5 cm. (44⅛ × 61⅝ in.) Düsseldorf, Alex Voemel (photograph Ides et Calendes, Neuchâtel)

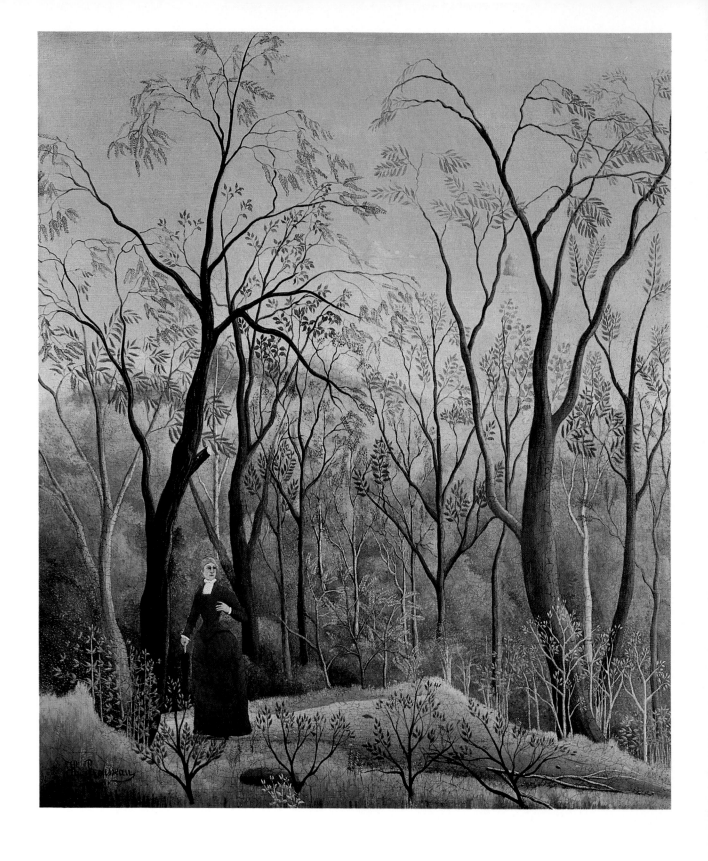

10. *The Walk in the Forest*. About 1886. Canvas, 71 × 60 cm. (28 × 23⅝ in.) Zürich, Kunsthaus

11. *A Carnival Evening*. About 1886. Canvas, 116 × 89 cm. (45⅝ × 35 in.) Philadelphia, Museum of Art

20

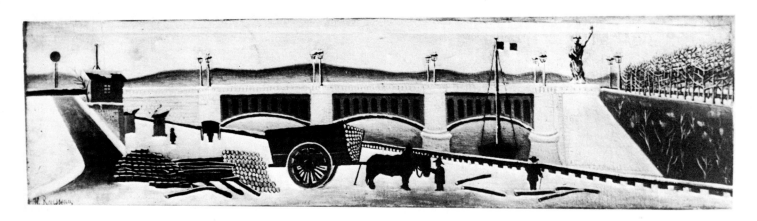

12. *View of the Pont de Grenelle.* About 1893. Canvas, 20.5 × 75 cm. (8⅛ × 29½ in.)
Paris, Goldschmidt-Rothschild Collection (photograph Ides et Calendes, Neuchâtel)

tendency to use brighter colours, with more contrast.

A lithograph (Rousseau's only known print) of this composition was published in January 1895 in *L'Ymagier*, a revue edited jointly by Alfred Jarry and Rémy de Gourmont (Plate 14). Although published some months after the painting had been exhibited at the Salon des Indépendants, it appears to show an earlier state of the composition, closer to the original illustration to *Le Tsar*. In making the painting itself, Rousseau introduced much larger trees to frame the composition at both sides, and brought the horse and rider more into the foreground, so that they dominate the composition in an altogether more startling and dramatic way, the girl's white dress making a vivid contrast with the black elongated silhouette of the horse.

Within a very few years Rousseau has enlarged the scope of his work to an astonishing degree and has proved himself capable of painting large and highly-finished compositions of great assurance. The self-portrait *Myself. Portrait-Landscape* measures 143 × 110.5 cm., *Surprise!* 130 × 162 cm., *A Centenary of Independence* 112 × 156.5 cm. and *War* 114 × 195 cm. This development seems moreover to have

been achieved independently of the work of his contemporaries. What, therefore, we may ask, is Rousseau's relationship to tradition? And how far is it possible to relate his work to that of other artists?

It is known that he often visited museums and that he obtained a copyist's card for the Louvre as early as 1884, but when he was asked which artists he liked best, he is reported to have said: 'You see I cannot remember all the names.' One can however make certain tentative deductions from his own paintings. The works of the great masters of the High Renaissance and the Baroque must have meant little to him; but on the other hand it would not be in the least surprising if he was attracted by the paintings of the fifteenth century. For example, the portrait of the journalist Edmond Frank is a bust portrait with the figure set against a landscape background (Plate 51); even the red fez seems to suggest an earlier period. One is reminded a

13. Illustration to the novel *Le Tsar* (published 1889, artist unknown)

14. *War.* About 1894. Lithograph, 22 × 33 cm. (8⅝ × 13 in.) (Kornfeld & Klipstein)

22

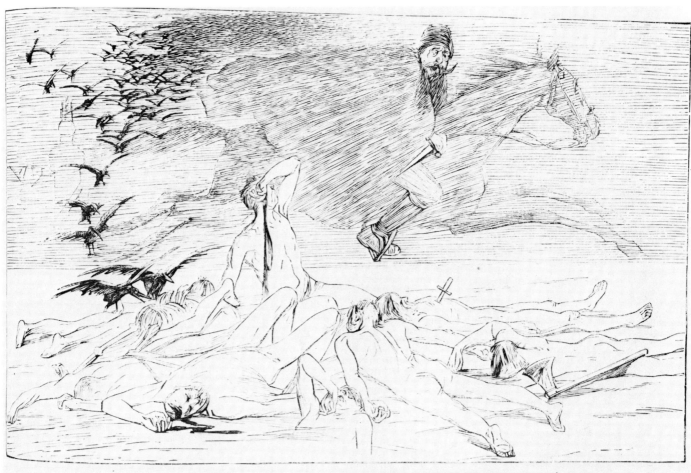

Partout où passait le mystérieux cheval noir, un malheur s'abattait, un crime était commis. (Voir la suite dans l'*Égalité.*)

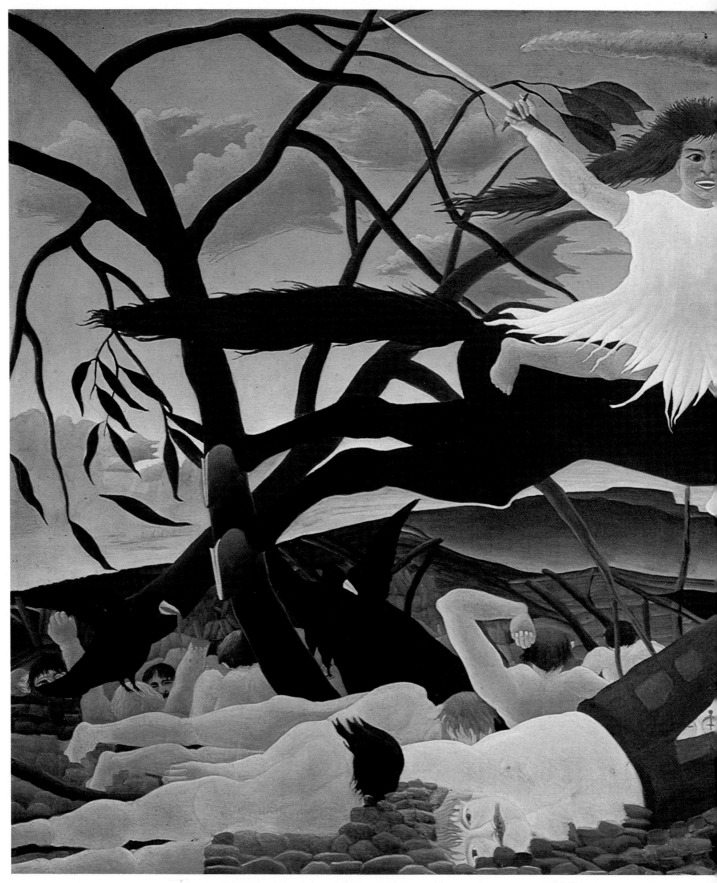

15. *War*. 1894. Canvas, 114 × 195 cm. (44⅞ × 76¾ in.) Paris, Louvre

little of certain portraits by Memling and it is perhaps not too far-fetched to see in the raised hand an echo of the praying hands from a diptych. But if this suggestion is correct, Rousseau has modernized the treatment in characteristic fashion by introducing a row of factory chimneys in the background and by placing a cigarette between the fingers. Although it was known for many years as a portrait of Pierre Loti, it was identified by Frank in 1952 as a replica of a portrait of himself which he commissioned from Rousseau in 1905 or 1906 and which was exhibited at the Salon des Indépendants in 1906 as *Portrait of M.F.* The factory chimneys were those which could be seen from the window of his apartment in Montmartre. Similarly the pair of very long narrow paintings of *A Centenary of Independence* and the *Pont de Grenelle* already referred to have the proportions and character of Italian predella or cassone panels even though they were probably done as projects for mural paintings, while the *Happy Quartet* (Plate 43), with its two naked male and female figures, its playful putto and dog in an idyllic pastoral setting, is reminiscent of the allegorical pictures of Lucas Cranach.

It seems likely therefore that Rousseau's study of the work of fifteenth and early sixteenth-century painters played some part in enabling him to crystallize his own mature style, and that in their pictures he found not only certain compositional devices he could take over and modernize, but also the use of areas of pure colour and pattern which could serve him as inspiration. Not for nothing has he sometimes been called a modern Paolo Uccello.

His relationship to the work of his contemporaries and near-contemporaries is still very much a matter for conjecture. The themes of his paintings are in the naturalistic and romantic traditions, but exact influences are difficult to pin down. Despite his professed admiration for leading French academic painters of the time, such as Clément, Gérôme, Bouguereau and Meissonier, there are few traces of any direct influence on his work. On the other hand he made a straight copy of a small painting by Delacroix of a *Tiger attacking a Lion*, which he inscribed *d'après E.D./Henri Rousseau*, and on several occasions used an obscure painting or drawing by some little-known artist, a work of no distinction in itself, as the basis for one of his own compositions, apparently without disclosing the source. Besides his transformation of the illustration to *Le Tsar* into a large painting that was very different, there are at least two instances of his making revised and improved versions of paintings by other artists: his *Tiger Hunt* (Plate 17) was based on a painting by Rodolphe Ernst called *Triumphal Evening*, which was exhibited at the Salon des Artistes Français in 1895 and his *View of Brittany* (Plate 22), which exists in two versions dated 1906 and 1907, was based on Camille Bernier's *Spring, Bannalec, Finistère*, a picture which was formerly in the museum at Angers. In both cases he seems to have worked not from the originals themselves but from reproductions, as the painting by Ernst was reproduced in *Le Monde Illustré* (Plate 16), and there was a lithograph by Eugène Pirodon after the painting by Bernier (Plate 21). Comparison of the *Tiger Hunt* with its source shows that Rousseau retained all the main elements of the composition but simplified and purified the forms, and rendered them in gorgeous, glowing colours. A realistic, photographic-like scene was transformed into something visionary and

16. Engraving after the painting by Rodolphe Ernst, *Triumphal Evening* (published in *Le Monde Illustré*, 12 October 1895)

17. *Tiger Hunt*. About 1895–7. Canvas, 38 × 46 cm. (15 × 18⅛ in.) Columbus, Ohio, Columbus Gallery of Fine Arts

26

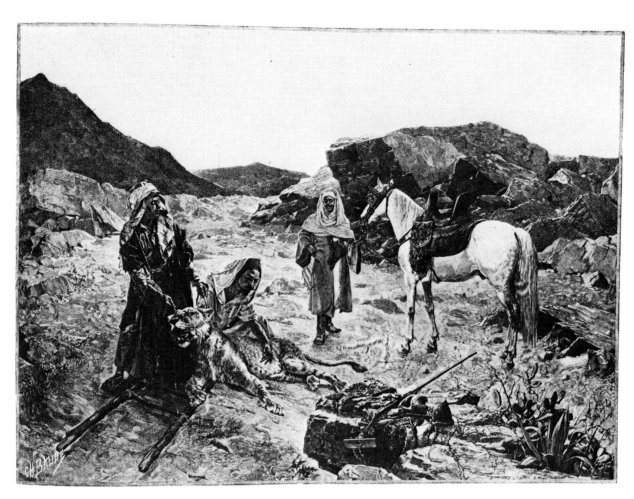

18. *Flowers of Poetry*. About 1890–1. Canvas, 38 × 46 cm. (15 × 18⅛ in.) Private Collection (photograph Acquavella Galleries, New York)

19. *Toll Station* (*L'Octroi*). About 1890–1. Canvas, 37.5 × 32.5 cm. (14¾ × 12¾ in.) London, Courtauld Institute Galleries

dream-like. Similarly the landscape by Bernier, which is very ordinary and banal, is given a strange individuality largely through an exaggeration of the twisted, gnarled forms of the trees and of the patterning of light and shadow on the ground. It may well be that Rousseau used other paintings and drawings as well in the same way, but that they are so obscure they have not yet been identified.

Although he seems to have been very little influenced by contemporary styles, Rousseau's love of clear precise forms and carefully constructed compositions shows that he was developing along lines similar to those of some of the most advanced of the younger painters. It would, no doubt, be incorrect to see in the Courtauld Institute's *Toll Station* any influence of Seurat. And yet there is a certain resemblance to Seurat's later work in its careful, slightly rigid arrangement of verticals and horizontals; its organization in a sequence of planes parallel to the picture surface; and even in the way the figures are seen square on from the front or from the back. Moreover, apart from Seurat and Puvis de Chavannes, Rousseau was almost the only French painter of the time who was consistently able to work with success on a large scale.

The portrait of a boy (Plate 23) now in the National Gallery, Washington, seems to have been painted within a year or two of the child on horseback in *War* and may have been one of the two pictures entitled *Portrait of a Child* exhibited at the Salon des Indépendants in 1894 and 1895. A reviewer remarked on 'his Japanese-like portraits' at the Salon des Indépendants in 1895, 'in which the heads are larger than the bodies,' and could well have had in mind this work, in which a shapeless child with a round, oversized head appears to straddle a range of crags like a monumental puppet. The dignity and gravity of the child in this strange setting make it one of the oddest

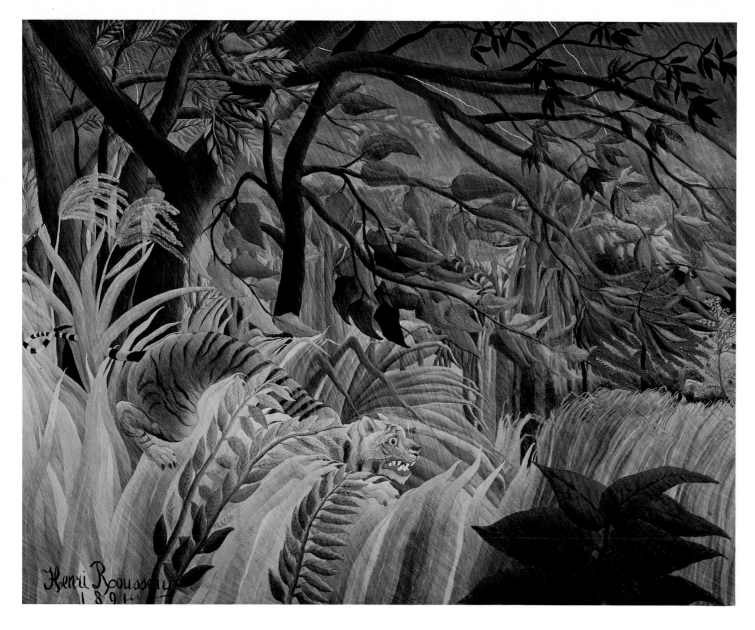

20. *Surprise!* 1891. Canvas, 130 × 162 cm. (51⅛ × 63¾ in.) London, National Gallery

and most unforgettable images of childhood in the history of painting, and it is possible that this picture served later on as the inspiration for several of Picasso's most startling child paintings of the late 1930s.

Similar in date, or perhaps a year or two later, is the portrait of a woman (possibly Rousseau's future second wife Joséphine) standing on a garden path against a background of highly-patterned flowers and shrubs, holding a pansy in one hand and an umbrella in the other (Plate 25). There is little structure in the body and the hands are over-large, but the dark silhouette of the billowing skirt and sleeves helps to fill the picture space and to make the figure dominate the composition in an overpowering and even rather alarming way. The fact that one's eye-level appears to be more or less in line with her waist, so that one looks down at her shoes and at the tiny kitten playing with a ball of wool at her feet, and up at her head, gives her the scale of a giantess;

21. Lithograph by Eugène Pirodon after Camille Bernier's painting, *Spring*, *Bannalec*, *Finistère*.
Paris, Bibliothèque Nationale

she takes on something of the character of an apparition from the dead or from a dream.

Among Rousseau's other portraits of this period was one of the writer Alfred Jarry, which was exhibited at the Salon des Indépendants in 1895 under the title *Portrait of Mme A.J.*—a confusion apparently caused by Jarry's long hair. Jarry, like Rousseau, came from Laval, where Rousseau knew his father. Born in 1873, he was just beginning to make himself known as a writer and as a wild and rebellious character; but the first performance of *Ubu Roi* on the Parisian stage, which was to earn him great notoriety, did not take place until December 1896. Jarry seems to have met Rousseau in 1894, and it was through him that Rousseau was commissioned by Rémy de Gourmont to make his lithograph of *War* for *L'Ymagier*. According to descriptions in the reviews, Rousseau's portrait depicted Jarry seated near a balcony dressed in black, and accompanied by his favourite animals: owls, a chameleon and a parrot. Unfortunately this picture, which may have been one of Rousseau's masterpieces, was destroyed by the sitter himself, who cut out his own image because he found it disturbing. By 1906, when Apollinaire saw it, part of the portrait had been burned and all that remained was the very expressive head.

22. *View of Brittany*. 1906. Canvas, 40 × 52 cm. (15¾ × 20½ in.)
Present whereabout unknown (photograph Ides et Calendes, Neuchâtel)

Rousseau's figure paintings of the 1890s such as these show an extraordinarily individual and powerful imagination expressed in a manner which is sometimes bizarre and ungainly, and with a vividness which tends to go hand in hand with unintentional humour. It is therefore hardly surprising that although his exhibits were placed in the furthest and least accessible rooms at the Salon des Indépendants, they became one of the great attractions of the exhibitions and visitors made a point each year of searching for them. People would gather round them, as at a side-show, and there would be waves of laughter.

Though Rousseau collected his press cuttings and stuck them in an album, he only rarely had the satisfaction of finding any that were favourable. Most of the critics tended to dismiss his work as hilarious and crudely incompetent. One of the first persons to single out his pictures for praise seems to have been the Swiss painter Félix Vallotton, when reviewing the Salon des Indépendants of 1891 in *Le Journal Suisse*: 'M. Rousseau becomes more amazing every year . . . it is always good to see a belief, whatever it is, so relentlessly

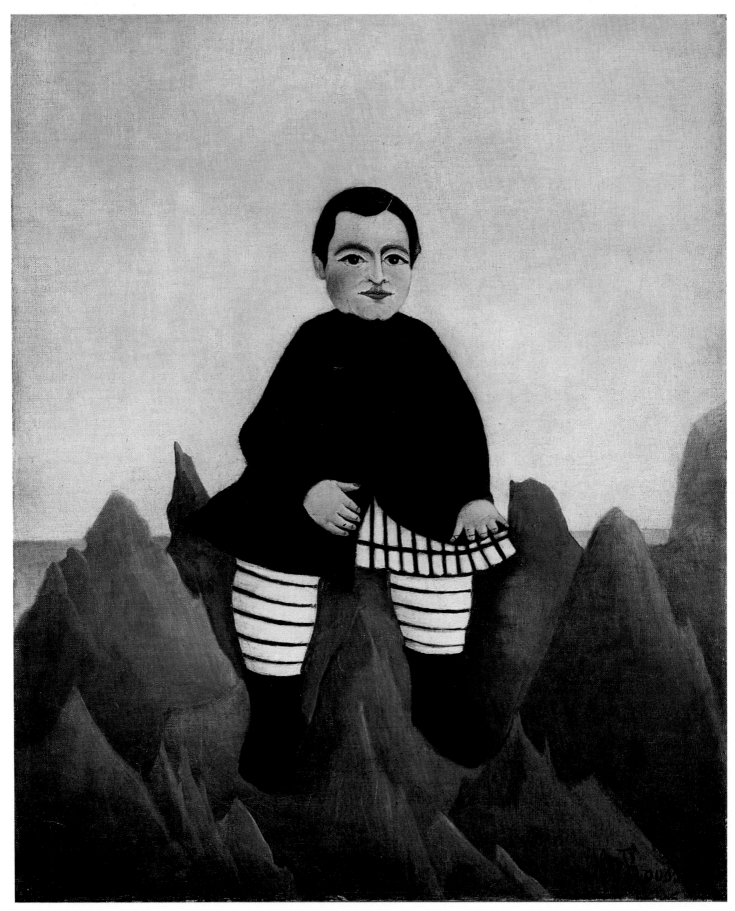

32

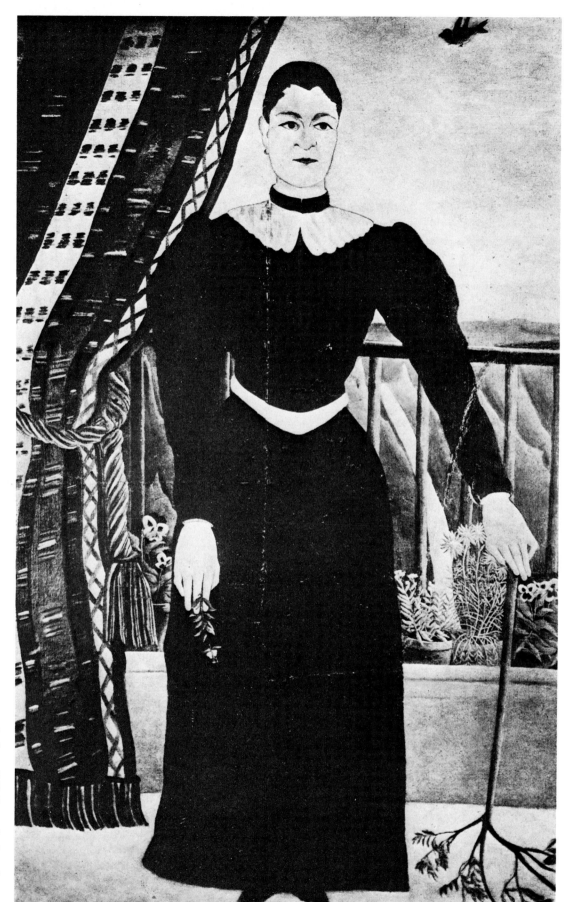

23. *Boy on the Rocks.* About 1894–5. Canvas, 55.4 × 45.7 cm. (21¾ × 18 in.) Washington, National Gallery of Art (Chester Dale Collection)

24. *Portrait of a Woman.* About 1896. Canvas, 150 × 100 cm. (59 × 39⅜ in.) Formerly collection of Pablo Picasso

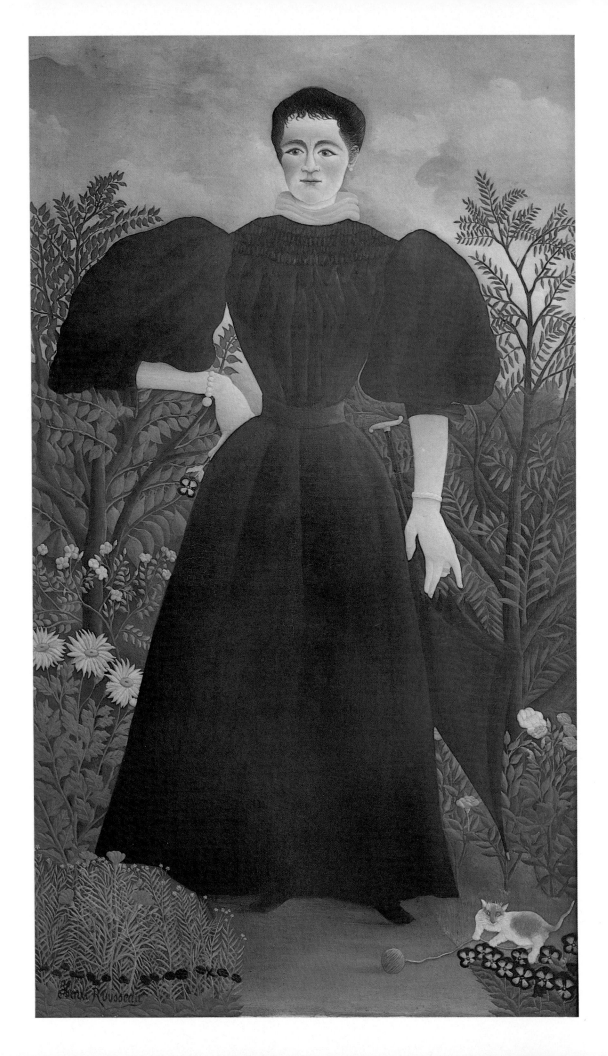

34

26. *View of the Bièvre at Gentilly*. About 1895.
Canvas, 38 × 45.8 cm. (15 × 18 in.) London, Tate Gallery (on loan from a Private Collection)

expressed. For my part I have a sincere respect for his efforts, and I prefer them a hundred times to the deplorable errors nearby.' But the most remarkable exception, far in advance of its time, was an article by Louis Roy in the *Mercure de France* of March 1895 in which he called Rousseau's *War* the most outstanding painting at the Salon des Indépendants of 1894 and added:

25. *Portrait of a Woman*. About 1895–7. 198 × 115 cm. (78 × 45¼ in.) Paris, Louvre

It has been for M. Rousseau as for all innovators. He proceeds from himself alone, he has the merit, rare today, of being absolutely personal . . . what an obsession, what a nightmare! What a powerful impression of insurmountable sadness! One would have to be of bad faith to dare to pretend that the man capable of suggesting ideas like these is not an artist.

27. *The Quarry*. About 1894–6.
Canvas, 47.5 × 55.5 cm. (18¾ × 21⅞ in.) New York, Private Collection

In addition to his figure pictures, Rousseau painted a number of small landscapes, almost all of Paris and the surrounding area. There are views of roads, of the Seine and its bridges, the Eiffel Tower and the Trocadéro, the Parc Montsouris, the Bois de Boulogne and the Buttes-Chaumont, the fortifications and the city gates. He also painted Malakoff and the villages along the Seine, the Oise and the Marne. The great boulevards and scenes of café life were not for him, nor did he paint the artists' quarter of Montmartre, as Utrillo was to do: his motifs were drawn from the unfashionable suburbs of the city, its streets and parks and the banks of its rivers. Even his paintings of the countryside (with the excep-

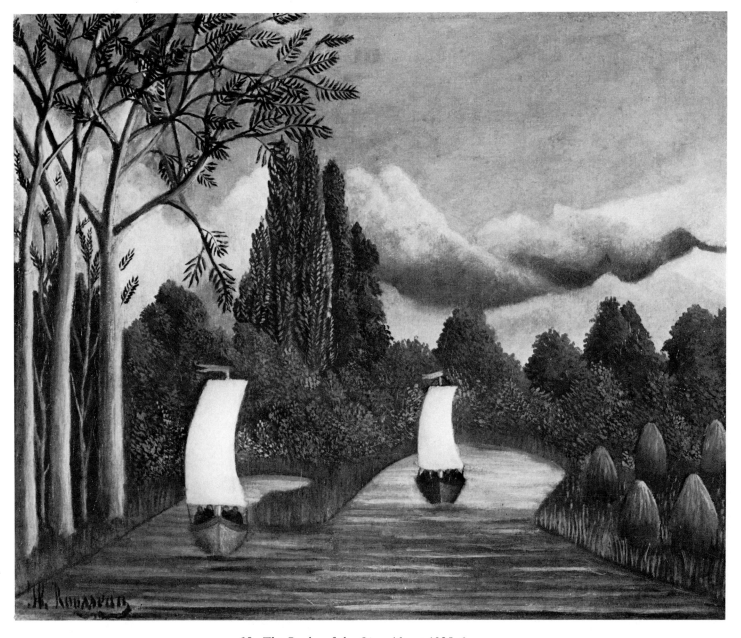

28. *The Banks of the Oise*. About 1905–6.
Canvas, 46 × 55 cm. (18⅛ × 21⅝ in.) Northampton, Mass., Smith College Museum of Art

tion of the *View of Brittany*, which was done from a lithograph) seem to show views within easy reach of the southern outskirts of the city. His landscapes depict a quiet, settled world, usually with one or more little anonymous figures out for a stroll, or people fishing. They do not have the drama of some of his work, but they are not devoid of poetry and strangeness.

Though the development is much less marked than in his figure paintings, one can trace certain definite changes in his landscape style, all related to an attempt to widen the range of his effects and to approximate more closely to the rendering of nature: thus the colours tend to become brighter and more varied, the trees have compact masses of

37

29. *Sketch for 'View of the Parc Montsouris'*. About 1895.
Canvas, 26 × 20 cm. (10¼ × 7⅞ in.) Paris, Private
Collection (photograph Ides et Calendes, Neuchâtel)

30. *View of the Parc Montsouris*. About 1895. Canvas,
74.5 × 47 cm. (29⅜ × 18½ in.) New York, Private
Collection

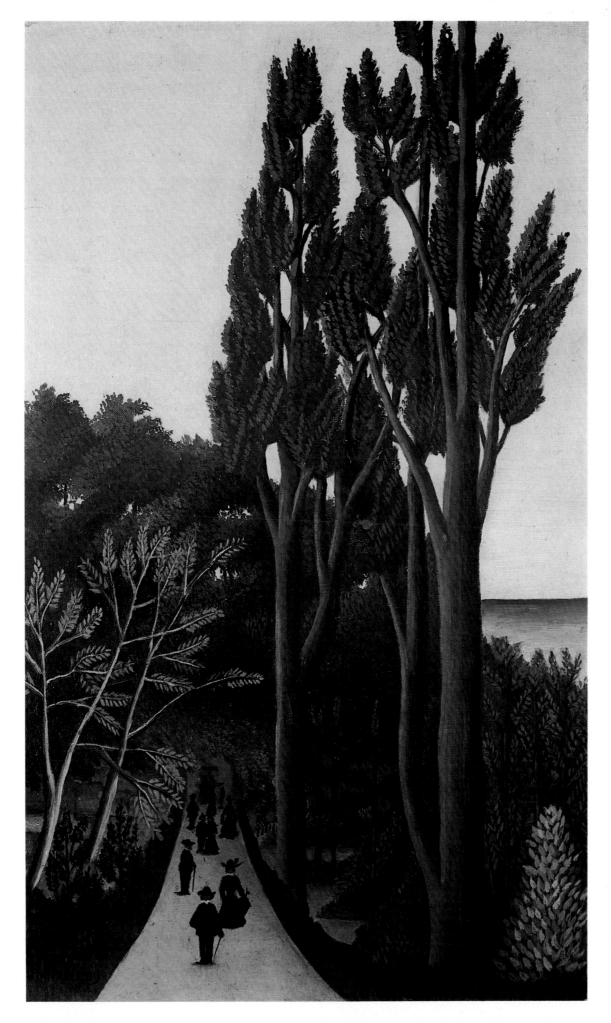

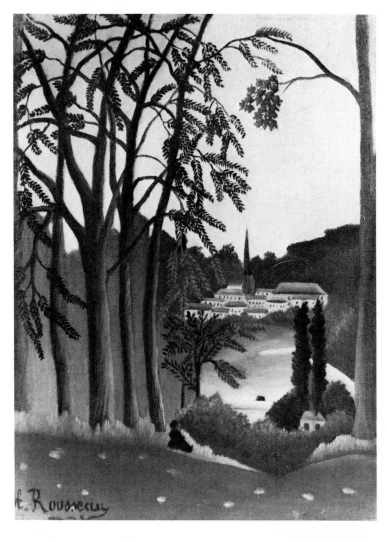

foliage, the treatment of the clouds is less stylized and more closely observed. The scenes are sometimes bright and sunny, and sometimes overcast, with heavy storm clouds. Not only does the impression of space become more successful but there is a tendency in a number of the later landscapes to accentuate depth by deliberately choosing a view down a road, a pathway or an avenue of trees. The recession is not always completely convincing (see for instance, the treatment of the road in the Carnegie Institute's *House on the Outskirts of Paris*; Plate 33), due to Rousseau's inadequate knowledge of linear perspective, but there is an undoubted gain in the later works in freedom and assurance.

As part of his search for a greater fidelity to nature, Rousseau began about 1895 to make quick, summary oil sketches direct from nature in preparation for his finished landscapes. These oil sketches, which are quite different from anything else he produced, are painted in a deft Impressionist-like technique, with soft-edged brushstrokes, dark shadows and vibrant highlights. He did not think of them as pictures but as indications for pictures. (He never approved of highly finished sketches or sketchy paintings and, like Seurat, made a clear distinction between his sketches and his finished pictures). The sketches have none of the emphasis on local colour which tends to be characteristic of naïve painting, but are tonal studies based mainly on shades of dull green, grey and black. They are quick impressions from nature which he elaborated

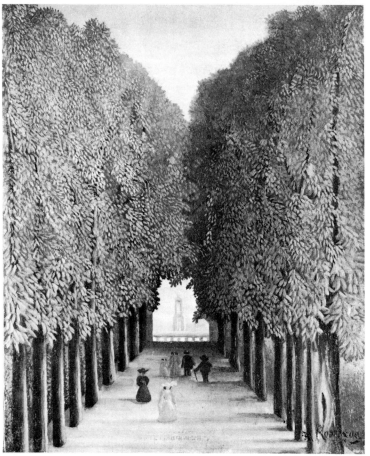

31. *View of Saint-Cloud, taken from the heights of Bellevue*. About 1895. Canvas, 22 × 16 cm. (8⅝ × 6¼ in.) New York, Sam Spiegel Collection

32. *Avenue in the Parc de Saint-Cloud*. About 1908. Canvas, 46.2 × 37.6 cm. (18⅛ × 14¾ in.) Frankfurt, Städtische Galerie

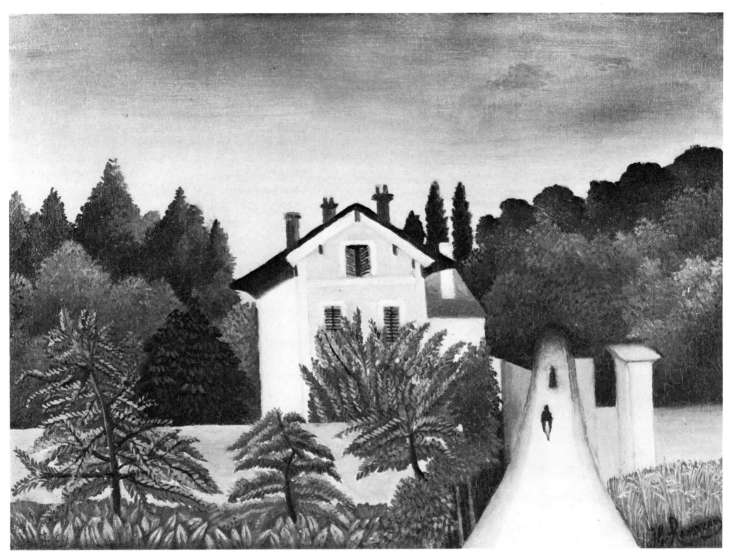

33. *House on the Outskirts of Paris*. About 1905–7.
Canvas, 35 × 46 cm. (13¾ × 18⅛ in.) Pittsburgh, Carnegie Institute, Museum of Art

in the studio. The earliest known example is perhaps the study for *View of the Parc Montsouris*, a picture which was probably exhibited at the Salon des Indépendants in 1895 (Plates 29,30). In this case Rousseau took the sketch simply as his starting-point and turned it into a very deliberately constructed and much more detailed composition, taller and narrower in proportion, with an emphasis on the towering height of the trees on the right, contrasted with the lower bushier trees on the left and the tiny figures placed at intervals along the path so as to mark out a zigzag progression into depth. This effect is achieved partly by stressing the verticals of the larger trees, which are shown complete with their branches and leaves and extend from top to bottom of the composition. The exaggeration

41

of the differences in scale is similar to what one finds in some of the figure paintings of the same period, such as the portrait of a woman in a garden with a kitten at her feet (Plate 25). The later sketches tend to be much closer to the finished pictures, presumably because he had become more adept by then at picking out the salient features when working direct from nature; but nevertheless he always made adjustments to the compositions when painting the final works, in order to strengthen their pictorial construction, and added one or more little figures.

On learning in 1895 that a book was being prepared on contemporary painters and sculptors under the title *Portraits du Prochain Siècle*, Rousseau appeared at the publishers with the following autobiographical note, together with a self-portrait drawn in ink:

Born at Laval in the year 1844, because of the lack of wealth of his parents was obliged at first to follow another career than that to which his artistic taste called him.

So it was only in 1885 that he made his beginnings in art after many mortifications, alone, with only nature as a teacher, and some advice from Gérôme and Clément. His first two creations were sent to the Salon at the Champs-Elysées; they were entitled *An Italian Dance* and *Sunset*. In the following year he created *Carnival Evening*, and *A Thunderbolt*. Then followed *Waiting, A Poor Devil, After the Feast, Parting, Dinner on the Lawn, The Suicide, To my Father, Myself*, portrait-landscape of the author, *Tiger pursuing Explorers, Centenary of Independence, Liberty, The Last of the Fifty-first, War*, a genre portrait of the author A.J. . . , also about 200 drawings in pen and pencil, and a certain number of landscapes of Paris and its surroundings. It was only after hard experiences that he managed to make himself known from among the many artists around him. He has perfected himself more and more in the original manner he has adopted, and is becoming one of our best realist painters. As a characteristic mark he wears a bushy beard and has joined with the Indépendants long since, believing that all liberty to create must be left to the inventor whose thoughts are elevated to the beautiful and the good. He will never forget the members of the press who have known how to understand him and who have sustained him in his moments of discouragement, and who have helped him to become the man he should be. Written in Paris, 10 July 95.

Henri Rousseau.

In this characteristic and charming declaration there are two statements which demand special comment. First there is Rousseau's remark that he had made his beginnings in art alone, with only nature as a teacher 'and some advice from Gérôme and Clément'. To find his name coupled with those of two of the leading academic painters of his day is at first sight rather surprising, to say the least. But it seems less odd when one learns that Clément became a close neighbour of Rousseau's in the Rue de Sèvres in 1881 or 1882. Being a kind-hearted man or perhaps in a moment of insight, he must have advised him to continue in the way he had begun. 'If I have preserved my naïvety', wrote Rousseau in 1910 to the critic André Dupont, 'it is because M. Gérôme, who was a professor at the Ecole des Beaux-Arts, and M. Clément, Director of Fine Arts at the Ecole de Lyon, always told me to preserve it . . . and it has also been said of me that I am not of this century. I cannot now change my manner, which I have acquired as a result of obstinate toil.'

The other statement by Rousseau which demands special comment is his claim that he is becoming 'one of our best realist painters'.

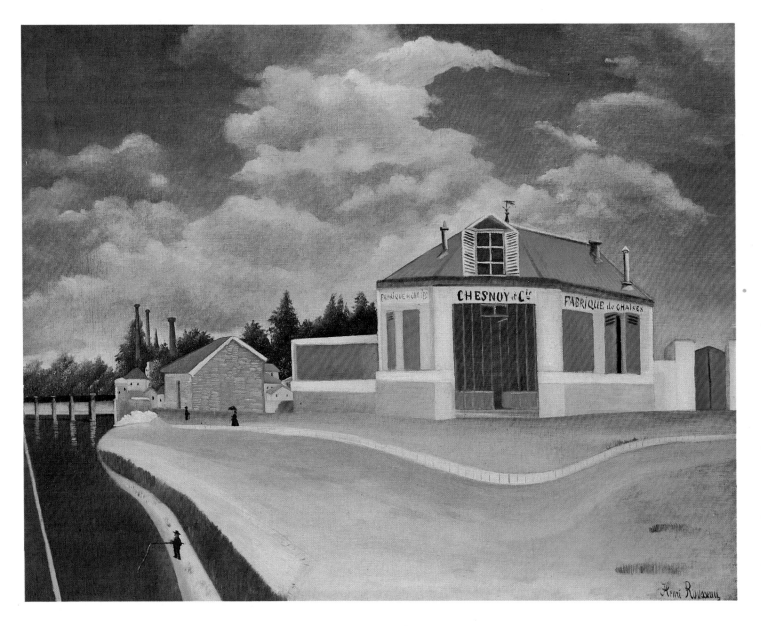

34. *The Chair Factory*. About 1897.
Canvas, 73 × 93 cm. (28¾ × 36⅝ in.) Paris, Louvre (Jeu de Paume, Walter-Guillaume Collection)

Realism is not something one associates with his work upon first acquaintance; nevertheless the claim has a certain validity. As has been said, his imaginative compositions apart, he drew his material from the world around him, particularly the suburbs of Paris, its parks and rivers, and the people of his acquaintance. Nothing seems to have delighted him more than an opportunity to introduce some new marvel of our mechanical civilization into his

43

35. *Sketch for 'View of the Ile Saint-Louis seen from the Quai Henri IV'*. 1909.
Oil on millboard, 18 × 26.5 cm. (7⅛ × 10⅜ in.) Providence, Rhode Island, Mrs Henry D. Sharpe Collection

pictures, whether it be the Eiffel Tower, factory chimneys, an aeroplane or a balloon.

Not only did he make a sustained attempt to depict nature more exactly, but his forms are realistic inasmuch as he insists on the individual character of each. Sometimes this is a very naïve and literal-minded realism as when, in painting portraits of Jarry and Apollinaire, he began by measuring the nose, mouth, ears, forehead, hands and whole body of his sitters, and then carefully transferred these measurements to the canvas, reducing them to the dimensions of the stretchers but without making any allowance for perspective. He is even reported to have held tubes of paint alongside Jarry's face to match the tints.

The famous *Sleeping Gipsy* of 1897 (Plate 37), now in the Museum of Modern Art in New York, shows Rousseau as complete master of the style which he had forged. It is

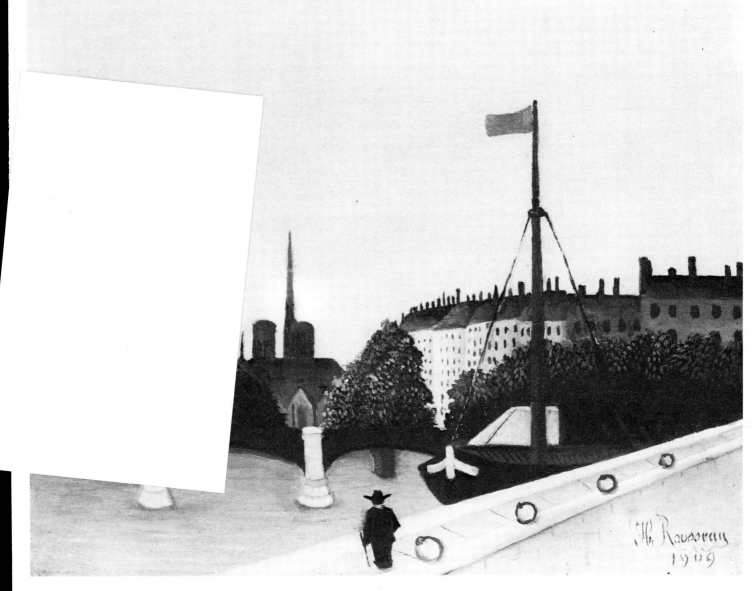

36. *View of the Ile Saint-Louis seen from the Quai Henri IV.* 1909.
Canvas, 33 × 41 cm. (13 × 16⅛ in.) Washington, D.C., The Phillips Collection

a picture to which he attached special import-
ance and in 1898 he wrote to the mayor of
Laval trying to sell it to his native town. He
described the composition as follows:

> A wandering negress, playing the mandolin,
> with her jar beside her (vase containing
> drinking water), sleeps deeply worn out by
> fatigue. A lion wanders by, detects her and
> doesn't devour her. There is an effect of

moonlight, very poetic. The scene takes
place in a completely arid desert. The gipsy
is dressed in oriental fashion.

It is a strange and magical picture, one of the
most original paintings of the nineteenth
century. This encounter on a moonlit night
in the desert of a lion and a sleeping negress
has a note of menace, yet it is calm, with a
trance-like stillness; it is much more than a

45

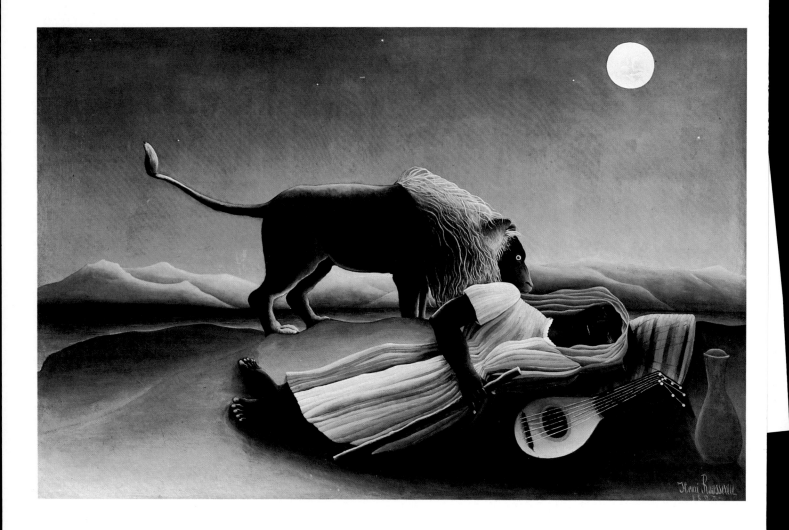

genre scene for it plays on the imagination like the early paintings of de Chirico. It is a picture which, in its dream-like mood, seems in some measure to foreshadow Surrealism. At the same time, the still-life of the mandolin and the jar, with their very simple, pure forms, anticipates certain early cubist still-lifes of about 1908 by Braque and Picasso. The gipsy's dress is striped in many colours like a rainbow. Despite her comical oddness, her doll-like proportions, she is as grand as a figure by Poussin. Though it is possible that the theme was partly inspired by Gérôme's highly realis-

tic paintings of lions roaming North African deserts, it has taken on a completely different and far more complex character.

Soon after the death of Clémence in 1888, Rousseau took his twelve-year-old daughter to live with his brother and sister at Angers, apparently on medical advice, and from then on he only saw her occasionally. The only other surviving child of the marriage, a son, remained with him in his studio in Paris until he died in 1897 at the age of eighteen. Deeply

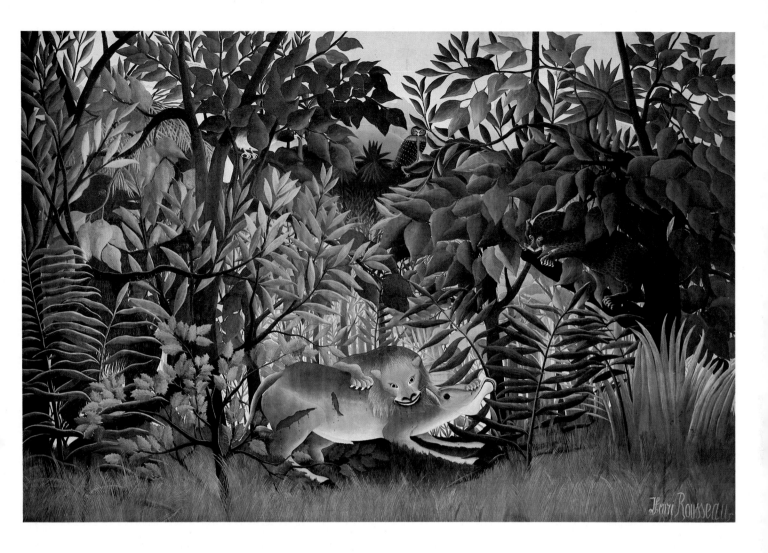

regretting the loss of Clémence, whom he adored, he seems to have hoped within a year or two to marry Mme Marie Foucher, a divorced woman, who was then living at the Palais du Louvre as maid-housekeeper to an architect and whom he may have met on one of his visits to the museum. When he painted his self-portrait *Myself. Portrait-Landscape* (Plate 8) in 1890 he inscribed her name on his palette with Clémence's, only to paint it out later on and substitute that of his second wife

Joséphine. However she married instead in 1891 a former soldier turned policeman, Frumence Biche, who died a year later as the result of an injury. Rousseau painted at least two portraits of Biche, including one full-length in military uniform, which was apparently done posthumously from a photograph, and it is possible that he also painted the Guggenheim Museum's *Artillerymen* (Plate 39) from an old group photograph of Biche with the battery he commanded as a sergeant in an

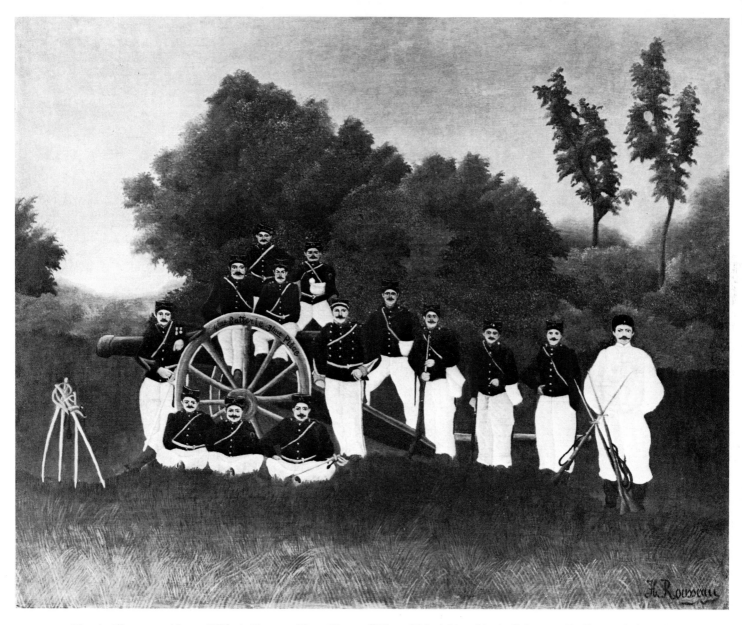

39. *Artillerymen*. About 1893–4. Canvas, 79 × 99 cm. (31⅛ × 39 in.) New York, Solomon R. Guggenheim Museum

artillery regiment. Exactly when he first met Joséphine is unrecorded, but there is a perhaps not very reliable tradition that he ridiculed her first husband, Le Tensorer, by depicting him in 1894 as the bearded corpse on the right of *War* whose face is being picked by crows (Plate 15). He eventually married her after she had become a widow, but she died only three years later in 1903 at the age of fifty-one.

Rousseau's painting known as *The Present and the Past* (Plate 40), which appears to be very indistinctly dated 1899, seems to have been painted, or more probably reworked and finished, at the time of his marriage to Joséphine. It depicts him, very formally dressed, in a charming spring-like landscape setting rich in flowers, with Joséphine beside him, both clutching a posy of flowers. Two heads appear floating in the sky above. According to Arsène Alexandre, writing in 1910, these further heads are those of

Joséphine's previous husband Le Tensorer and Clémence, but the possibility cannot be ruled out that the male head above is Rousseau's younger self. In any case the picture in its present form undoubtedly commemorates his first and second marriages. At the base of the frame is an inscription in verse:

Etant séparés l'un de l'autre,
De ceux qu'ils avaient aimés,
Tous deux s'unissent de nouveau
Restant fidèles à leur pensée.

Separated one from another
From those they had loved,
Both are united anew,
Remaining faithful in their thought.

It was exhibited at the Salon des Indépendants some years later, in 1907, under the title *Philosophical Reflection* (*La Pensée Philosophique*). On style, it appears to be earlier than 1899 and may have been begun soon after Le Tensorer's death in December 1895 as a sort of engagement picture of Rousseau and Joséphine, then reworked at the time of his marriage, when he reduced the amount of his own hair, repainted the face of the woman and added the two heads above, in the sky. The date would have been added at that time.

As Rousseau believed in ghosts, the spirits of the dead were very real to him. Uhde describes how he once turned to some visitors who were watching him paint and asked them: 'Did you notice how my hand was moving?'

'Of course Rousseau, you were painting.'

'No, no,' he answered, 'not I. It was my dead wife who was here and who guided my hand. Didn't you see her or hear her? "Keep at it Rousseau," she whispered, "that is going to come right in the end." '

The innocence of Rousseau, his unworldliness and his childlike trustfulness, is attested by all those who knew him, and there are many stories of the tricks played on him by

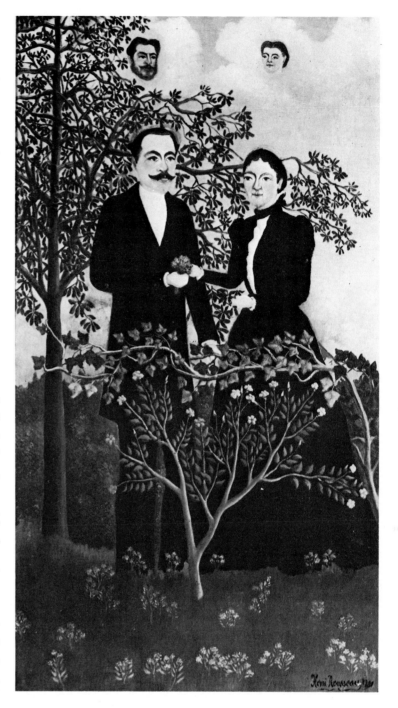

40. *The Present and the Past.* About 1896–9. Canvas, 84 × 47 cm. (33⅛ × 18½ in.) Merion, Pa., Barnes Foundation (photograph © 1978 by the Barnes Foundation)

people who could not resist the temptation to tease and mock him. Thus there is the story of the elderly man who called at his studio pretending to be Puvis de Chavannes and was warmly received by Rousseau, who said to him, without showing the least surprise: 'I have been expecting you for a long time.' Then there was the joker who persuaded Rousseau that all he needed to do to be taken on by the illustrious Galerie Durand-Ruel was to take his pictures and tip M. Durand-Ruel 100 sous, and those who told him that he had been invited to a reception by the President of the Republic. 'I arrived at the main door,' he explained to his friends afterwards, 'but as I had not brought my invitation card, I was told I could not be allowed to enter. When I insisted, M. le Président himself came out, tapped me on the shoulder and said: "What a shame Rousseau, that you came in ordinary dress; you see, everyone is in evening dress; I can hardly receive you like that today; come back another day." ' By little lies like these, he tried to protect his pride. Some acquaintances of his even announced that he had been created Commander of the Légion d'Honneur and staged a banquet in his honour at which he was ceremonially invested with a red cravat—a farce which nearly got him into serious trouble, as the police threatened to prosecute him for wearing a decoration to which he was not entitled. It is hardly surprising, therefore, that when another painter who was also named Henri Rousseau was awarded the *palmes académiques* in 1904, he thought that this had been awarded to himself and put *palmes académiques* after his name on formal occasions for several years afterwards. Despite all the indignities and disappointments he had to suffer, he had a firm belief in the merits of his own work and therefore took it as perfectly natural that he should be given the signs of recognition he so much longed for.

His struggle to be able to continue to paint

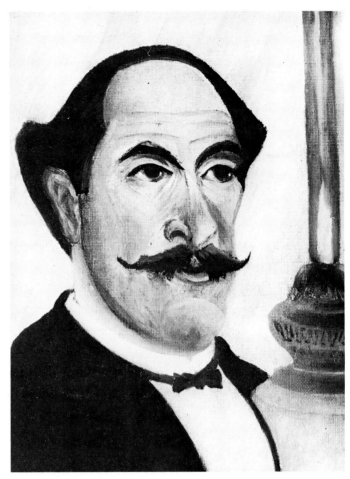

41. *Portrait of the Artist*. About 1902–3. Canvas, 24 × 19 cm. (9½ × 7½ in.) Formerly collection of Pablo Picasso

and meet all his bills was a real one. The pension from the octroi service had to be supplemented in various ways, for the occasional sale of a picture brought in little to meet his expenses. For several years after his retirement he seems to have practised as a decorative painter, painting signs for bakers and other local shopkeepers, and described himself on his visiting cards of the time as 'Artiste peintre décorateur'. Besides participating in the competition for the decoration of the town hall of Bagnolet in 1893, he competed unsuccessfully for the decoration of the town halls of Vincennes in 1898 and Asnières in 1900, but never got beyond the first stage. Despite Louis Roy's enthusiastic article in the *Mercure de France* in 1895 and

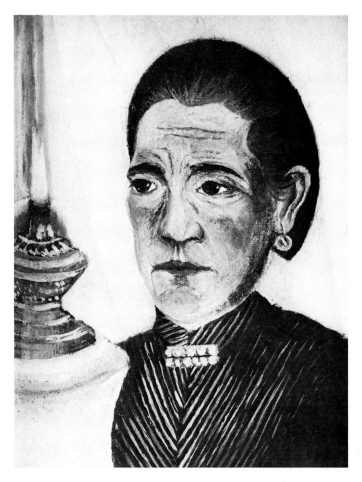

42. *Portrait of the Artist's second wife Joséphine.* About 1902–3. Canvas, 22.5 × 17.5 cm. (8⅞ × 6⅞ in.) Formerly collection of Pablo Picasso

the publication of his lithograph in *L'Ymagier*, it was a long time before he began to make any real progress. Always anticipating success which did not come, he began in 1896 to obtain paint and canvas on credit, and fell steadily more and more into debt until by November 1901 he owed his supplier Paul Foinet as much as 614 francs 80. M. Foinet was eventually obliged to take him to court in December 1904 and Rousseau was ordered to pay off the arrears at the rate of 10 francs a month. In order to raise money he spent some time copying transcripts for a lawyer, became sales inspector for the *Petit Parisien* for his district and even wrote a five-act drama *The Vengeance of a Russian Orphan*, which he submitted unsuccessfully in 1899 to the

Théâtre du Châtelet. This play, the second he wrote and sent to the Châtelet (the first being a comedy *A Visit to the Exhibition of 1889*, which he submitted in 1889), was written in collaboration with a certain Mme Barkowski, probably a pseudonym for Joséphine. (Taking wide interest in the arts, Rousseau was not only a painter but played the violin, the clarinet and several other instruments, composed music, including a waltz *Clémence* which was published in 1904, and wrote poetry and plays). After his second marriage his wife opened a small stationery shop where she tried to sell his pictures, and Rousseau became in late 1901 or early 1902 the teacher of a Sunday morning painting course for adults at the school of the Association Philotechnique, a huge adult education centre of left-wing philanthropic leanings with over 600 teachers. He evidently took his teaching there quite seriously, as one of his first concerns on being arrested in 1907 was that he would have to miss his class the following Sunday. Then from about 1903 he also began to give private painting and music lessons in his own studio, putting a plaque on the door which read:

LESSONS IN ELOCUTION
MUSIC
PAINTING AND SINGING

For the modest sum of 8 francs per month (later increased to 12 francs) he gave private lessons in drawing and watercolour painting to children and teenagers on Saturday afternoons from 2-5 p.m., and for adults on Thursdays from 8-10 p.m., the sessions for adults including work from live models. There were also so-called examination days, at which the parents would take seats around the room, while the pupils would perform their pieces of music (an opportunity to tease him by playing the wrong selections or deliberately playing wrong notes).

Being always in great need of money,

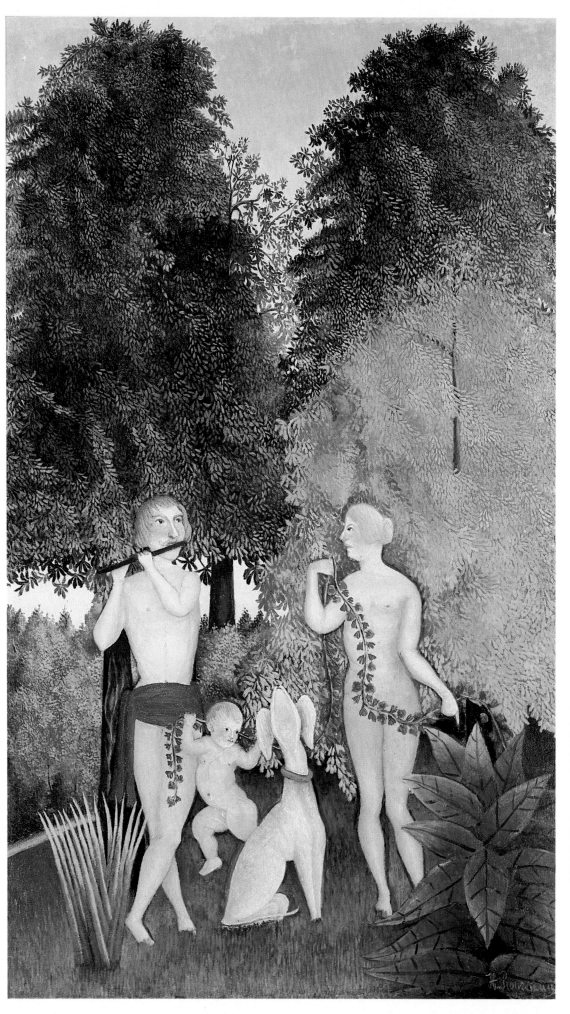

43. *Happy Quartet*.
About 1902. Canvas,
93.5 × 57 cm. (36¾ ×
22⅜ in.) New York,
Mr and Mrs John
Hay Whitney
Collection

44. *To fête Baby!*
(*Pour fêter Bébé!*)
About 1903. Canvas,
100 × 81 cm. (39⅜ ×
31⅞ in.) Winterthur,
Museum of Art

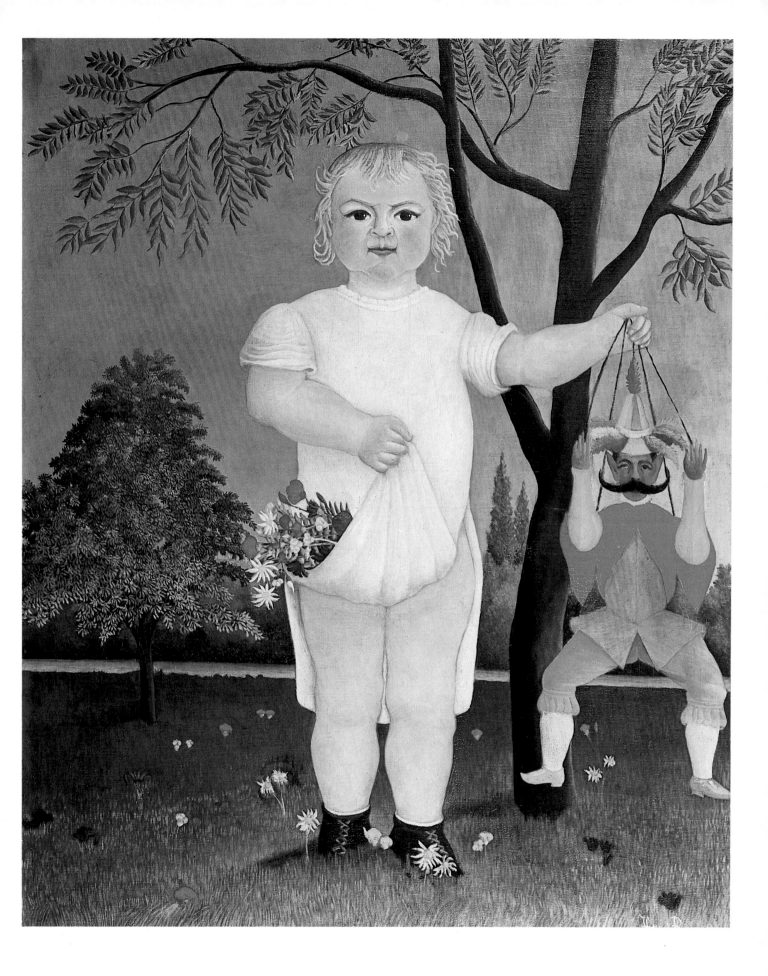

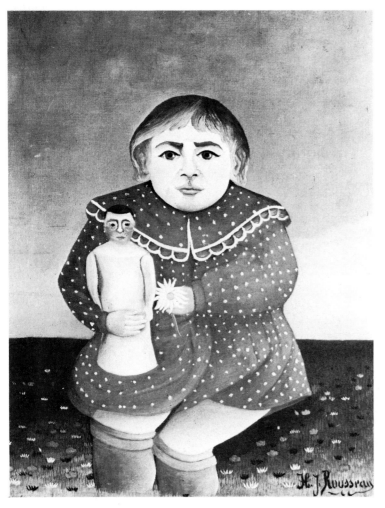

Rousseau was happy to sell his landscapes to the people of the neighbourhood or to receive commissions for portraits, but the sums he was paid were very small. The most he ever received seems to have been 300 francs for the painting of a child with a puppet (apparently the picture exhibited at the Salon des Indépendants in 1903 as *To fête Baby!* Plate 44) and the child's parents could not afford even that, and had to relinquish the picture in settlement of a small laundry bill. The largest of his studies of children, it shows the child standing in a frontal pose of an almost hieratic kind, in a beautiful park-like landscape setting, clutching his chemise full of wild flowers in one hand and holding a splendidly costumed puppet in the other. The treatment, though still highly individual, has become less eccentric than in some of the figure paintings of the mid 1890s, and the structure and drawing are firmer and more assured. There are bold contrasting areas of clear, positive colour, and black and white.

The *Girl in Pink* in the Philadelphia Museum of Art (Plate 46) has been identified as a portrait of Charlotte Papouin, the daughter of one of Rousseau's neighbours, painted about 1907. Rousseau, who was her younger sister's godfather, painted this picture as a way of thanking the Papouins for their many kindnesses to him in his poverty, including frequent invitations to join their family circle for meals. Despite its rather rigid frontality, the picture was painted from life, at least in part, and the slabs of stone on which the young girl is standing were almost certainly included as a reference to M. Papouin's trade as a stonemason.

M. Juniet (or Junier), the subject of *The*

45. *Portrait of a Child.* About 1908. Canvas, 67 × 52 cm. (26⅜ × 20½ in.) Paris, Louvre (Jeu de Paume; Walter-Guillaume Collection)

46. *Girl in Pink* (*Charlotte Papouin*). About 1907. Canvas, 61 × 46 cm. (24 × 18⅛ in.) Philadelphia, Museum of Art

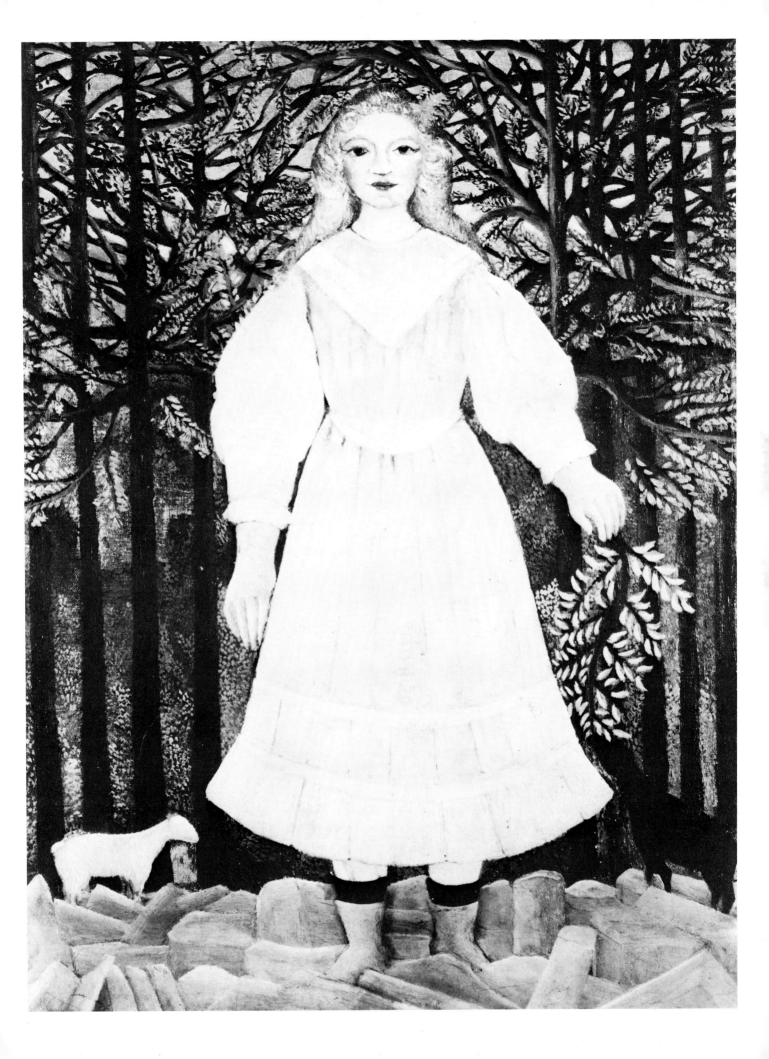

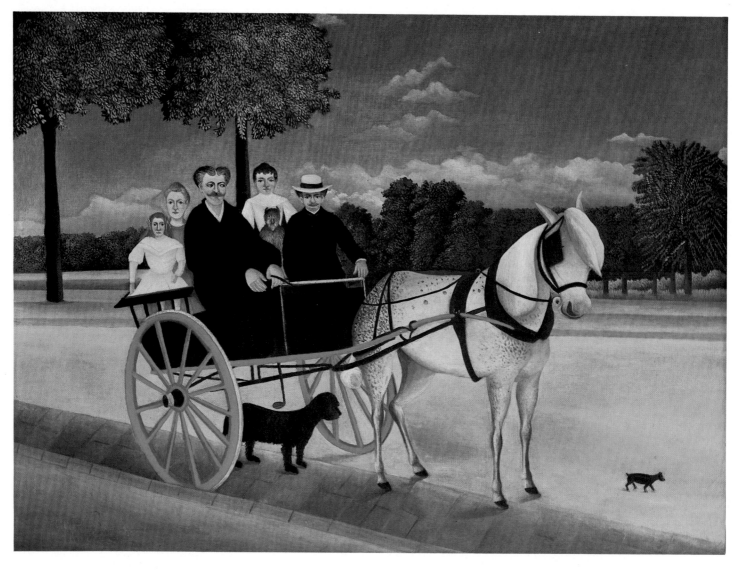

47. *The Cart of Père Juniet*. 1908.
Canvas, 97 × 129 cm. (38⅛ × 50¾ in.) Paris, Louvre (Jeu de Paume; Walter-Guillaume Collection)

*Cart of Père Juniet* of 1908 (Plate 47), was a local greengrocer. As he had recently acquired a fine dappled horse of which he was very proud, it was agreed that Rousseau should paint him and his family with their cart and horse, in settlement of a grocery bill. The picture was done from a photograph which still exists, plentifully spattered with paint, and there is also another photograph of them taken at the same time showing Monsieur and Madame Juniet standing beside the cart. Comparison with the photograph shows that Rousseau made a number of changes, such as extending the composition upwards to take in more of the trees, and making the big dog rather smaller and moving it more to the

48. *A Country Wedding*. About 1905. Canvas, 163 × 114 cm. (64⅛ × 47⅞ in.) Paris, Louvre (Jeu de Paume; Walter-Guillaume Collection)

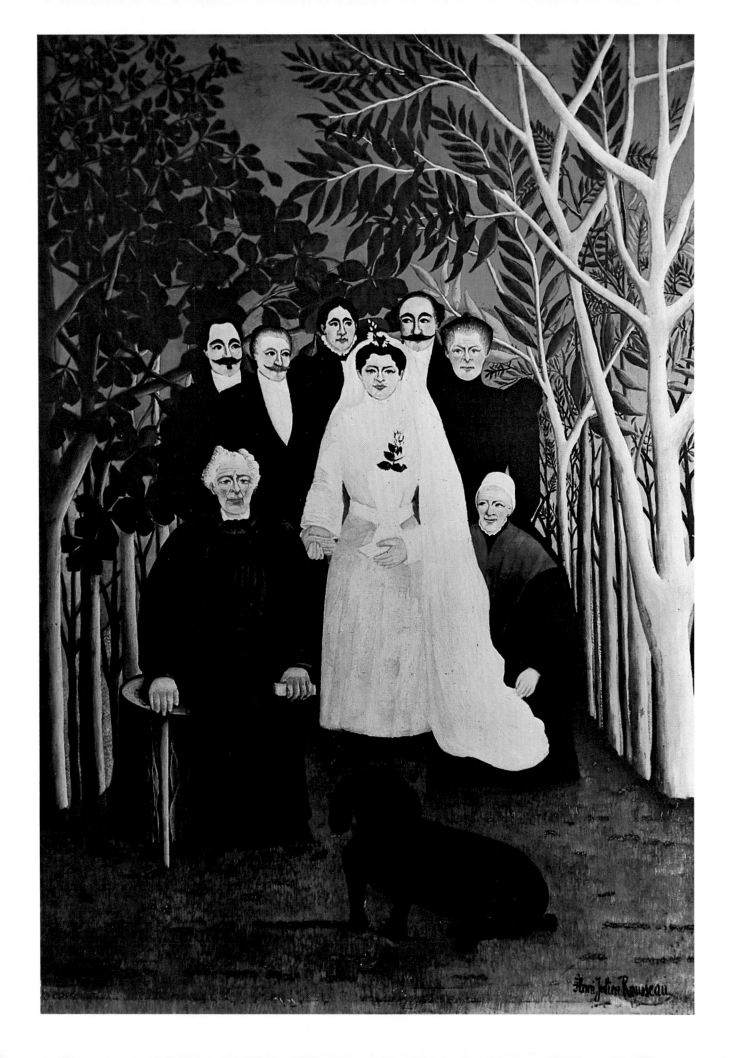

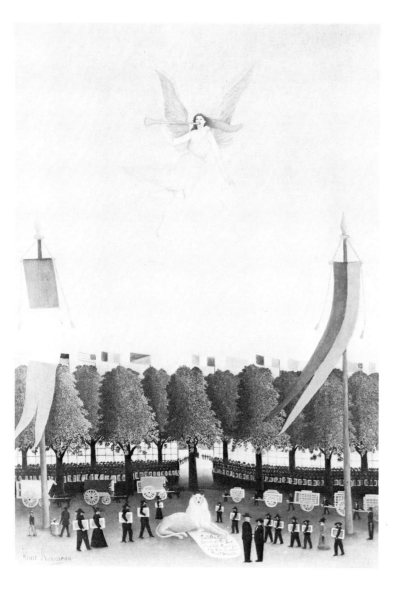

left, so that it actually appears to be standing underneath the cart. The perspective of the spokes has clearly caused Rousseau some difficulty, but the composition as a whole is beautifully balanced and spacious, with everything exactly in its place, while the colour and tonal contrasts are rich and masterly. The figures, though stiff and doll-like, have great dignity and appear to be well pleased with themselves in their handsome equipage. According to Robert Delaunay, the man with the hat seated alongside M. Juniet is Rousseau himself.

In *A Country Wedding* (Plate 48), exhibited at the Salon des Indépendants in 1905, the wedding party are set well back in the picture space, with a rather comical dog in the foreground serving as a *repoussoir*. There is a contrast between the interlocking areas of white and rich black of the clothes and the lively pattern formed by the foliage. Though it appears to have been painted from a photograph, it does not seem to have been a commissioned portrait as it remained in Rousseau's studio until it was sold to Jastrebzoff in August 1910, and the identity of the sitters is unknown. But again it shows Rousseau's social consciousness, his concern with the life and outlook of the class of small shopkeepers, artisans and minor officials to which he himself belonged. His works like these are friendly, good-humoured paintings, full of human sympathy and warmth.

One of the first persons from the world of the arts to buy pictures by Rousseau was Georges Courteline, the well-known humorous writer and satirist, who started to form a collection of paintings by naïve artists in the last years of the nineteenth century—the first collection specifically devoted to this type of work. This 'Museum of Horrors', as he called it, was intended mainly as an illustration of human eccentricity and absurdity, and included from about 1906 two paintings by

49. *Liberty inviting the Artists to take part in the 22nd Exhibition of the Artistes Indépendants.* About 1906. Canvas, 175 × 118 cm. (68⅞ × 46½ in.) Hamburg, Kunsthalle (on loan)

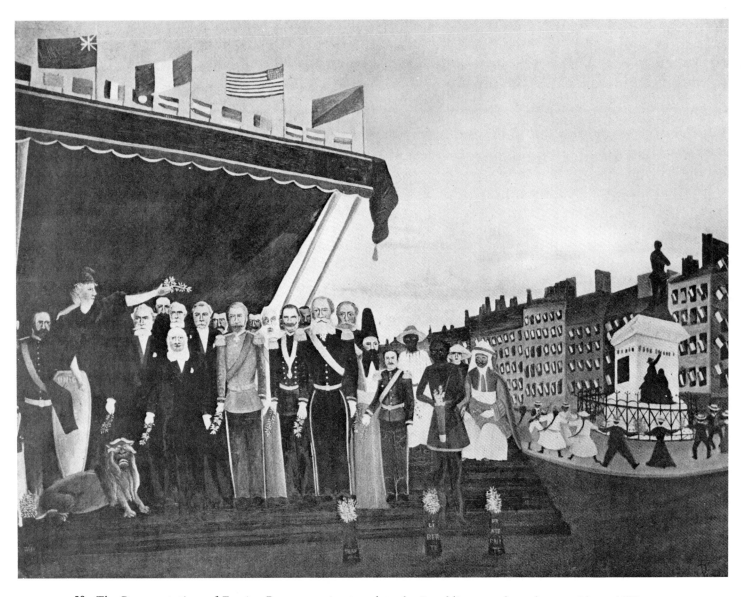

50. *The Representatives of Foreign Powers coming to salute the Republic as a token of peace.* About 1907.
Canvas, 130 × 161 cm. (51¼ × 63⅜ in.) Formerly collection of Pablo Picasso

Rousseau: *Liberty inviting the Artists to take part in the 22nd Exhibition of the Artistes Indépendants* (Plate 49), which had been exhibited at the Salon des Indépendants of 1906, and the version now in the Kunsthaus, Zürich, of the *Portrait of Edmond Frank* (Plate 51). It was almost certainly Courteline himself who re-entitled the latter *Portrait of Pierre Loti* because of a certain resemblance to the famous novelist, just as he gave other pictures in his collection such fanciful titles as *The Half-Cooked Virgin* and *The Mausoleum Regattas*. Though Courteline subsequently changed the name of his collection to 'Museum of Ingenuous Effort', it is doubtful whether this really indicated any greater understanding on his part of the merits of some of the works; and when years later the *Portrait of Edmond*

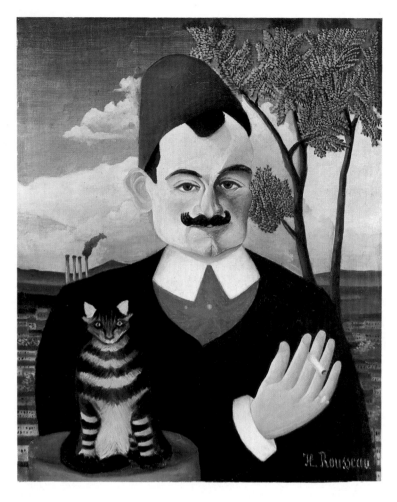

51. *Portrait of Edmond Frank*. About 1906. Canvas. 61 × 50 cm. (24 × 19⅝ in.) Zürich, Kunsthaus

*Frank* which he had once owned was placed on sale by the leading dealer Paul Rosenberg, priced at about 6,000 francs, he simply could not understand how such a high price could be asked for a picture he had always regarded as a joke.

The beginning of a genuine appreciation of Rousseau's work amongst a steadily widening circle of friends and admirers, including some of the foremost avant-garde artists of the day, seems to date from the inclusion of his paintings in the newly-formed Salon d'Automne in 1905, 1906 and 1907 as well as at the Salon des Indépendants. The most important of the paintings with which he made his first appearance there in 1905 was *The Lion being hungry . . .* (Plate 38), a picture which seems to have been the one previously exhibited at the Salon des Indépendants in 1898 under the different title *The Struggle for Life*, and which was therefore probably his second jungle picture. It was hung in one of the principal rooms, which had a sculpture by Maillol in the centre, and its huge size, strange subject-matter and decorative qualities attracted a number of mainly favourable comments in the press. Though the Fauve paintings by Matisse, Derain, Vlaminck and Rouault were the great sensation of this Salon, Rousseau's painting was one of those included in the famous double-page spread in *L'Illustration* of 4 November 1905 devoted to the Salon d'Automne and was reproduced alongside works by such artists as Cézanne, Vuillard, Matisse, Derain and Rouault. In the following March it was bought by Vollard for 200 francs and was the first of his works to be purchased by a dealer.

The poet Guillaume Apollinaire was introduced to Rousseau by their mutual friend Alfred Jarry in 1906, and subsequently became a warm admirer and supporter of his work. Robert Delaunay likewise met Rousseau in 1906 and persuaded his mother to commission

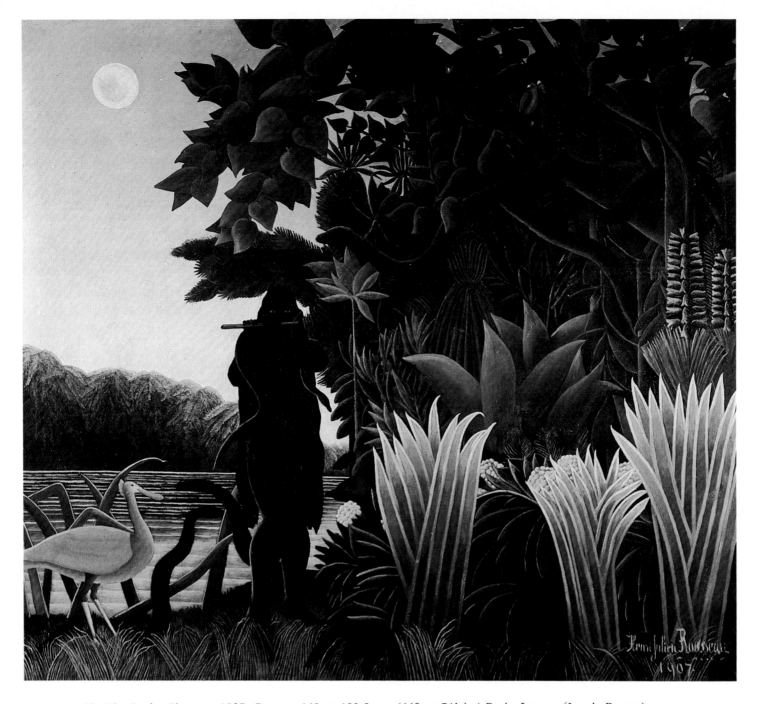

52. *The Snake Charmer*. 1907. Canvas, 169 × 189.5 cm. (66⅜ × 74½ in.) Paris, Louvre (Jeu de Paume)

the painting known as *The Snake Charmer* (Plate 52), which was inspired by her own reminiscences of her visit to India. Among those who met Rousseau at gatherings of the élite of the world of art at Mme Delaunay's home were the American painter Max Weber, who was then studying at Matisse's school, and the German collector, critic, dealer and art historian Wilhelm Uhde, who became a lifelong champion of Rousseau and naïve painting and who published the first of his books on Rousseau as early as 1911, the year after Rousseau's death. The other great enthusiasts for Rousseau's painting were

Picasso, who seems to have met him towards the end of 1907 through Jarry and Apollinaire; the Russian painter Serge Jastrebzoff, who signed himself Ferat; his sister the Baronne Oettingen, who wrote under the pseudonym Roch Grey and painted under that of d'Angiboult; and the Italian artist and writer Ardengo Soffici, for whom Rousseau painted the still-life of 1910 now in the Mattioli collection (Plate 65).

All these artists and writers were attracted to Rousseau both by his paintings and by the singular charm of his personality. Max Weber, for instance, described his first impression of him as that of a 'round-shouldered genial old man, small of stature with a smiling face and bright eyes' and spoke as follows of his first visit to Rousseau's studio: 'On the way home after this first visit to Rousseau's studio, which I shall never forget as long as I live, I felt that I had been favoured by the gods to meet one of the most inspiring and precious personalities in all Paris.' Similarly Robert Delaunay has related how he loved to spend hours in Rousseau's studio, watching him paint. 'I was attracted by that tranquillity, that plenitude.' Sometimes there would be one or two old men also painting there, friends and pupils of Rousseau's, usually producing work of a hopeless ineptitude. 'He is making progress,' Rousseau would say.

Though there are a few instances in which one can point to direct echoes of Rousseau's paintings in the work of Picasso, Delaunay and others at this period and later, their main significance for the artists who were developing towards Cubism seems to have been the extraordinary realism which Rousseau could achieve while ignoring visual conventions. It is probably no coincidence that the new interest in Rousseau took place at the same period as the discovery of the artistic importance of negro art, and that some of the same artists were involved in both. 'We are the two

great painters of the age,' Rousseau once told Picasso, 'you in the Egyptian style, I in the modern style.'

In 1908 Rousseau began to hold soirées in his studio which became as celebrated in their own way as the 'Tuesdays' of Mallarmé. His chairs would be lined up around the walls of the room. On the floor lay the cheap carpet a shopkeeper had let him have in exchange for three of his pictures. Jugs of wine stood ready on the table. Formal invitations were sent out and a printed programme prepared, which was lettered by Rousseau himself and run off by him in red or violet ink by means of a gelatine process:

> M. Rousseau hereby invites you to honour with your presence and your talents the very private and artistic soirée that will take place on Saturday 10 July 1909, at 2 bis rue Perrel.
>
> H. ROUSSEAU
>
> Please tell your friends.

And here is one of the programmes:

SOIREE ON 14 NOVEMBER 1908
held by
M. Henri ROUSSEAU at His Studio
2 bis rue Perrel

— ORCHESTRA —

Ave Maria..........GOUNOD
The Pierrots' March..........BOSC
Réginette..........BOSC
Babble..........GILLOT
The Two Brothers..........ROUSSEAU
LA MARSEILLAISE

Madame FISTER with songs from her repertoire.
Mademoiselle JEANNE with songs from her repertoire.
M. ROUSSEAU (*violin solo*) performing his works and creations.

*All guests are invited to perform.*

The guests comprised an extraordinary variety of people drawn from the different milieux in which he now moved. Besides artists and writers, both famous and totally unknown, there was always a number of Rousseau's art or music pupils, as well as local tradesmen

62

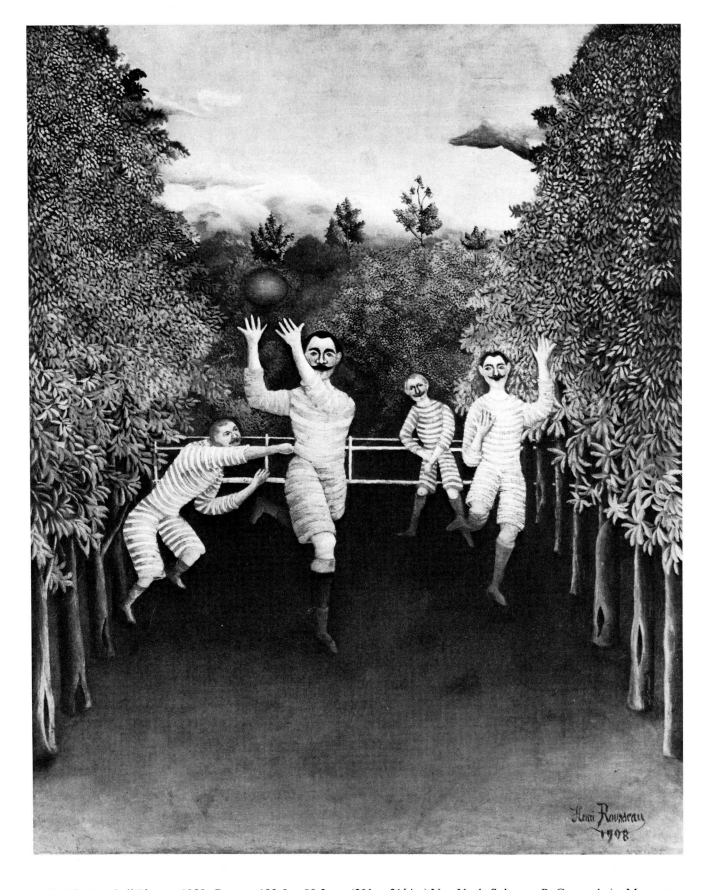

53. *The Football Players*. 1908. Canvas, 100.5 × 80.3 cm. (39½ × 31⅝ in.) New York, Solomon R. Guggenheim Museum

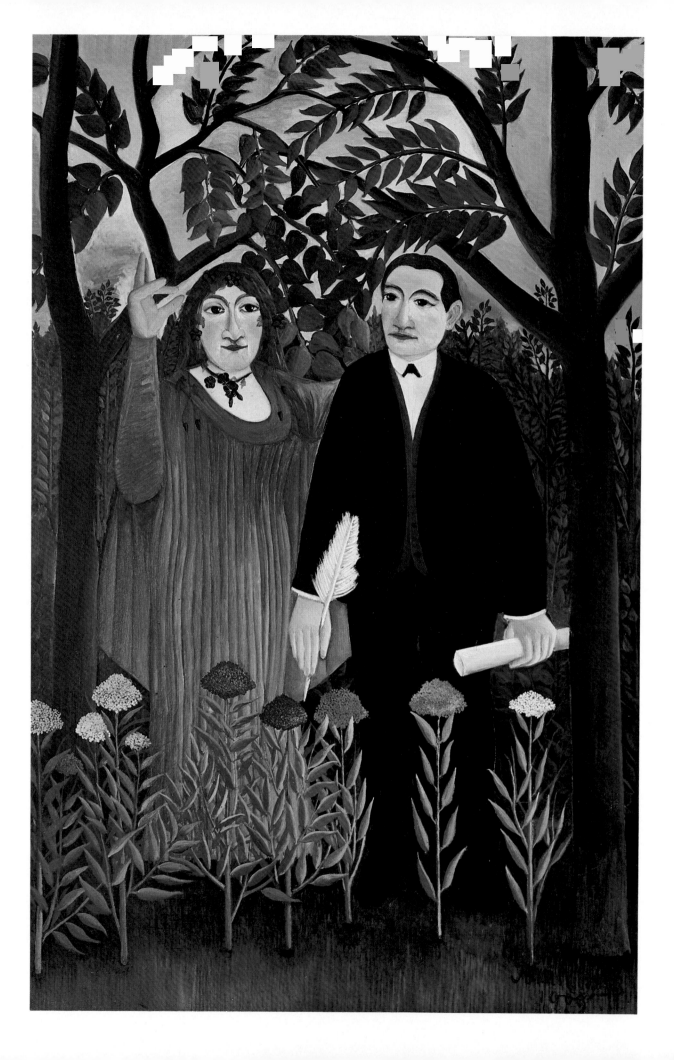

and their wives, elderly retired officials from the octroi service, women with flowered hats on the tops of their heads, children and babies.

The concerts invariably began with the 'Marseillaise'. Henri Rousseau, as first violin, directed the orchestra, composed of his pupils: a mandolin, a flute, a cornet, and so on. Max Weber, who had a fine tenor voice and had sung in synagogues, was much in demand as a soloist. Afterwards, there was a great deal of drinking, laughter and horseplay.

The high point of Rousseau's recognition—one might say his apotheosis—was the famous 'banquet' given by Picasso in his honour in November 1908 to celebrate his purchase of one of Rousscau's major works, the painting of a woman in front of a curtain (probably the picture exhibited at the Salon des In-dépendants in 1896 as *Portrait of Mme M.*), which he had found in Père Soulier's shop of second-hand goods priced at 5 francs (Plate 24). The banquet took place in Picasso's studio at the Bateau Lavoir, which was decorated for the occasion with strings of Chinese lanterns, and with a special raised seat like a throne for Rousseau himself. Many of the guests (who included Marie Laurencin and Braque, and writers like Apollinaire, Max Jacob, André Salmon and Gertrude Stein) gathered before-hand at a nearby bar, and the atmosphere was already relaxed and full of expectation by the time a knocking at the door announced the arrival of Rousseau himself, accompanied by Apollinaire and carrying his violin in one hand. After waiting for several hours for the dinner to arrive, Picasso remembered that he had made the mistake of ordering it for the following day, so some were sent out to collect whatever food could be obtained at the pastry-cooks' shops and restaurants of the neighbour-hood, and of course more drink. Afterwards Rousseau brought out his violin, a sort of violin for children, and played several of his own compositions and music for the guests to dance to. An accordion (played by Braque) and a harmonica joined in. The warm applause filled him with great satisfaction despite the fact that hot wax kept dripping on to his head from one of the Chinese lanterns, with persistent regularity, until it formed a mound like a clown's hat. Apollinare recited a poem which he had improvised in his honour, Rousseau sang all the songs from his reper-toire, the bottles were emptied, and Leo and Gertrude Stein took Rousseau home at dawn, sleepy and content.

Rousseau was painting at this same period a portrait of Apollinaire with Marie Laurencin (who was then Apollinaire's mistress) for which the sittings began in October or November 1908, and which was exhibited at the Salon des Indépendants in 1909 under the title *The Muse inspiring the Poet* (Plate 54). It shows Apollinaire standing in an outdoor setting, apparently based on a corner of the Luxembourg Gardens, with a scroll of paper in one hand and a quill pen in the other, while a solemn robed figure beside him—a very massive version of Marie Laurencin, who was actually rather slim—raises one hand in poetic invocation. In December, when the picture was nearly finished, Rousseau had the idea of adding a row of sweet williams (*oeillets de poète*) in the foreground, but, mistaking the flowers, painted stocks instead. When the painting came back from the Salon des Indépendants he therefore began a second, slightly larger version (the one now in the Kunstmuseum, Basle), with sweet williams and with certain other modifications designed to make the composition bolder and more rhythmical. It is a curious fact, as Apollinaire

54. *The Muse inspiring the Poet.* 1909. Canvas, 146 × 97 cm. (57½ × 38⅛ in.) Basle, Kunstmuseum (photograph Hans Hinz)

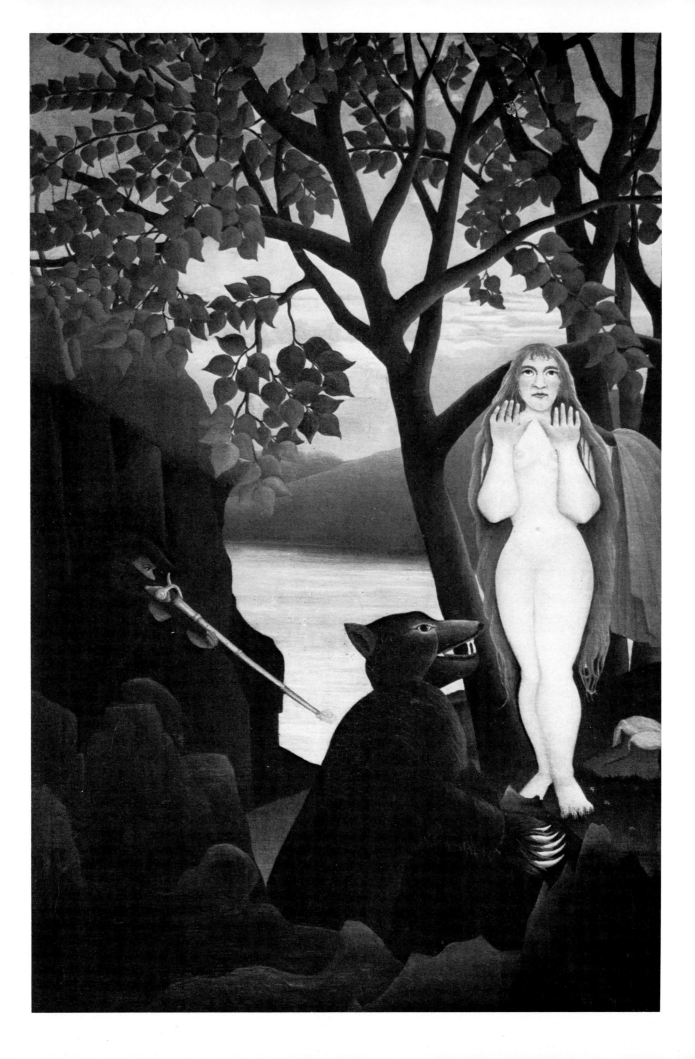

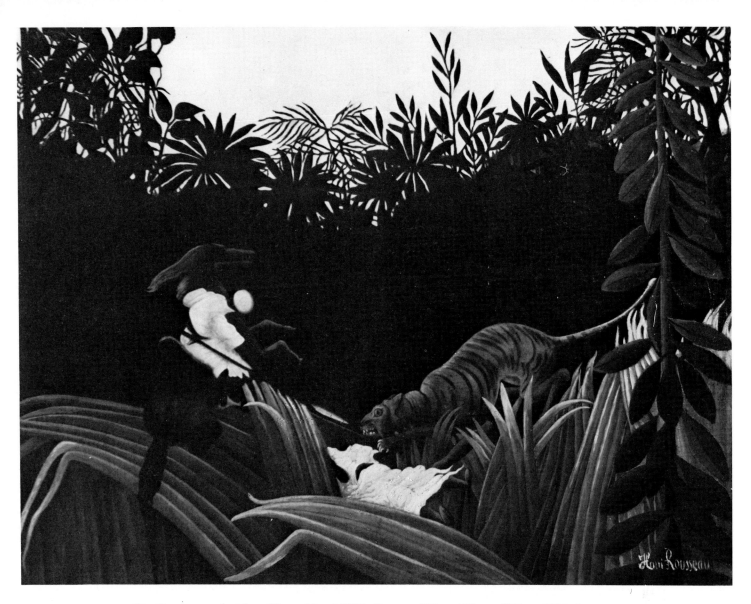

56. *Scouts attacked by a Tiger*. About 1904. Canvas, 130 × 162 cm. (51⅛ × 63¾ in.)
Merion, Pa., Barnes Foundation (photograph © 1978 by the Barnes Foundation)

himself pointed out, that when the first version was exhibited at the Salon des Indépendants the press were unanimous that it bore absolutely no resemblance to him; yet no one had disclosed that it was his portrait.

The jungle pictures which Rousseau exe-

55. *Unpleasant Surprise*. About 1900. Canvas, 195 × 130 cm. (76¾ × 51⅛ in.) Merion, Pa., Barnes Foundation (photograph © 1978 by the Barnes Foundation)

cuted in the last years of his life and which brought him recognition differ in one fundamental respect from *Surprise!* of 1891 (Plate 20). *Surprise!* was a picture full of movement. In Rousseau's later jungle pictures there is a frozen stillness. The vegetation is profuse and luxuriant, yet everything is beautifully ordered and lucid. Each form is depicted with sharp definition, almost every leaf turned towards us to show its characteristic shape.

67

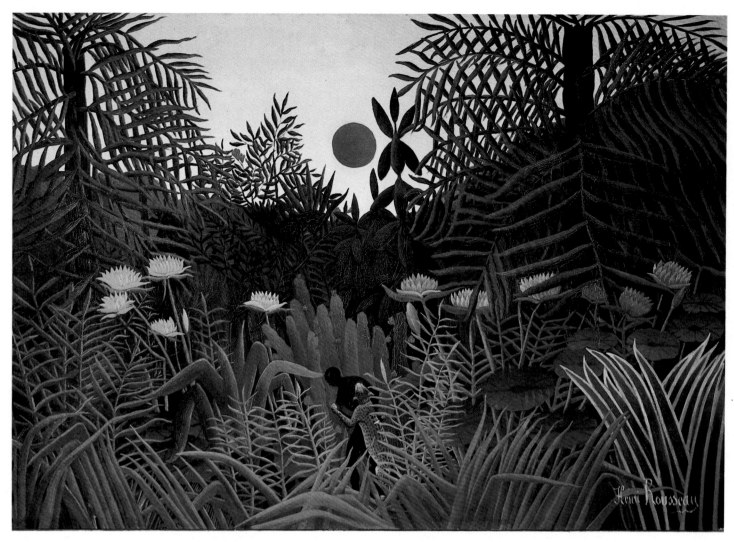

57. *Negro attacked by a Jaguar*. About 1910. Canvas, 114 × 162.5 cm. (44⅞ × 64 in.)
Basle, Kunstmuseum (photograph Hans Hinz)

Yet in spite of the profusion of details, each picture is a perfect unity: nothing jumps, everything is in its place. There is always something going on in the jungle, usually either some amusing monkeys at play or an incident of brutal savagery, such as a negro attacked by a jaguar or a tiger attacking a buffalo. The mood that these pictures evoke, with their strangeness and latent menace, is extraordinarily convincing, yet the origin of Rousseau's inspiration remains an enigma.

Rousseau himself referred to these works as 'Mexican pictures', and it has been suggested that behind the curious enlargement of leaves and flowers lie half-forgotten memories of the extraordinary landscape around Vera Cruz. On the other hand it seems unlikely that Rousseau went to Mexico at all, and the wild animals are mostly African or Indian. Botanists have identified a number of

58. *Merry Jesters* (*Joyeux Farceurs*). About 1906. Canvas, 146 × 114 cm. (57½ × 44⅞ in.) Philadelphia, Museum of Art

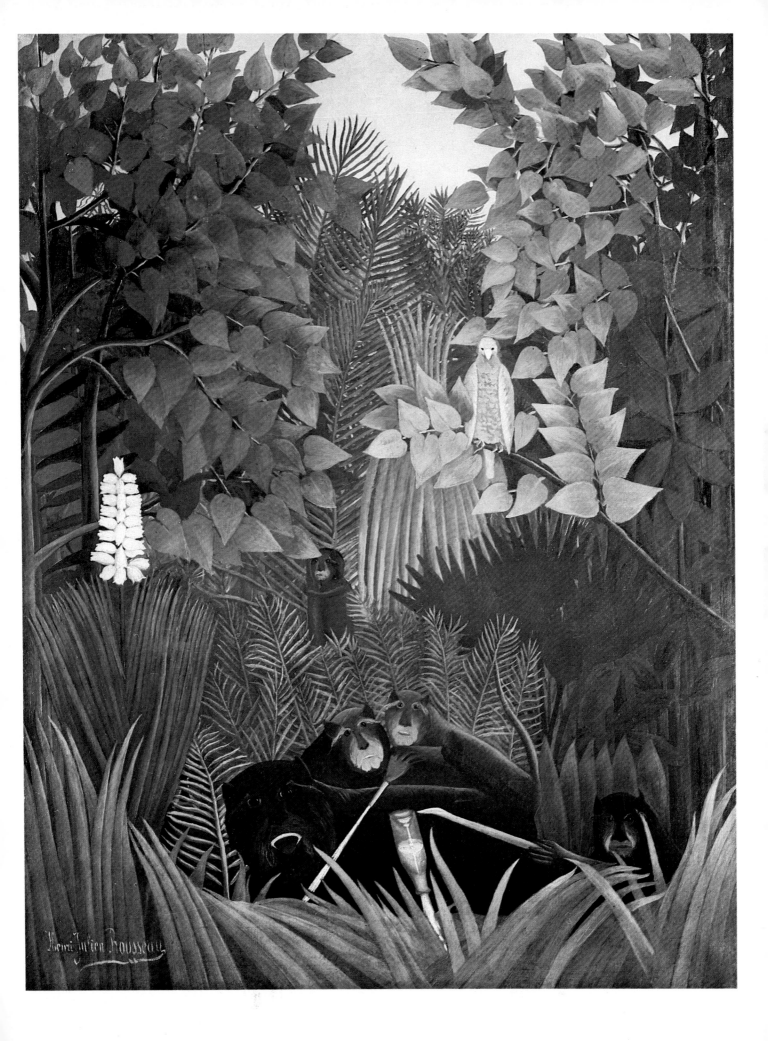

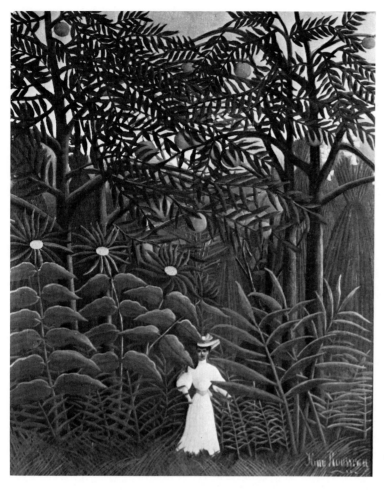

59. *Woman walking in an exotic Forest.* About 1908. Canvas, 100 × 81 cm. (43¼ × 31⅞ in.) Merion, Pa., Barnes Foundation (photograph © 1978 by the Barnes Foundation)

possession of his daughter. Published by the Grands Magasins 'Aux Galeries Lafayette' in Paris, it contains about two hundred photographs of animals with an instructive text. Most of the animals in the jungle pictures seem to have been based on illustrations of lions, tigers, jaguars, monkeys, flamingos, buffalos, snakes and so on in this book. Sometimes a pose is taken out of context and radically transformed, as for example a chimpanzee with its arms raised clutching the hands of its keeper is turned into a monkey swinging through the branches of a tree, while a photograph of a jaguar playing with its keeper in a cage at a zoo was made to serve as the basis for the sinister jaguar and its victim in *Negro attacked by a Jaguar* (Plate 57).

But it was not only the photographs that provided inspiration. The commentaries beneath the plates, written for children and highly evocative, must also have had a strong effect on him. For instance, the note on the jaguar reads as follows:

In certain parts of the New World, almost regularly at dawn and sunset, the cry of the jaguar is heard over very great distances . . . the animal only leaves its shelter at night, lies in wait among the bushes, awaits its prey, throws itself on its back while uttering a loud cry, puts one paw on its head, raises its chin with the other and so breaks the skull without having to use its teeth. Although large in size, it climbs on the trees with as much agility as a wild cat, and wages cruel war on the monkeys. At night time, its boldness is unsurpassed; and of ten men eaten by jaguars, to the knowledge of M. d'Azara, two were carried off in front of a big camp fire.

the plants, all of which were probably available at the Paris conservatory. It is known that Rousseau was in the habit of visiting the hothouses of tropical plants in the Paris zoo; and their lush vegetation, together with the wild animals in the vicinity, must have played an important part in inspiring these works.

Further light has been thrown on the origin of these jungle pictures by the discovery of an animal book for children called *Bêtes Sauvages*, which was found in Rousseau's studio at the time of his death and then passed into the

According to Apollinaire, Rousseau was sometimes so overcome when painting works like

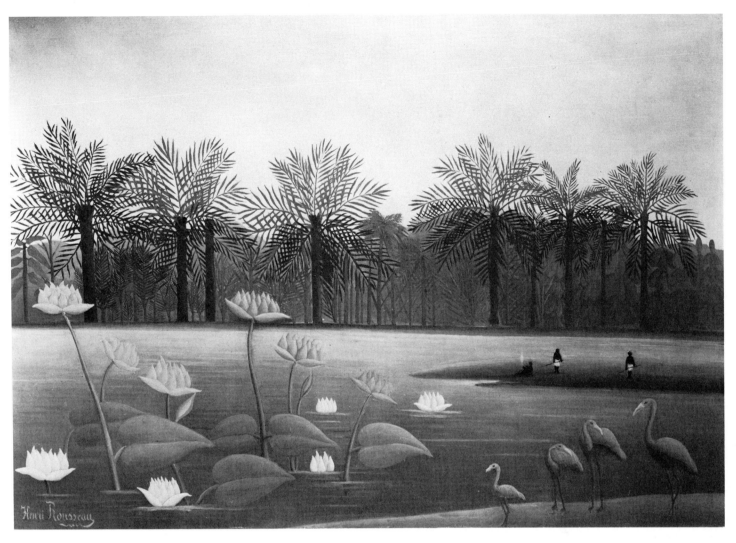

60. *Flamingos*. About 1907. Canvas, 114 × 162 cm. (44⅞ × 63¾ in.)
New York, Charles S. Payson Collection (photograph Ides et Calendes, Neuchâtel)

these that he would become terrified and, all a-tremble, would be obliged to open the window.

In all these jungle pictures Rousseau creates a strongly lighted distance, against which he silhouettes the darker forms of the trees or foliage. Plane upon plane is piled up in intricate design, usually with two or three animals to focus the eye on the foreground. In *Merry Jesters* (Plate 58) a group of monkeys seem to be playing with a milk bottle and a back scratcher, while one is tickling its companion with a reed; and in *Exotic Landscape* (Plate 67) a monkey is eating an orange, while two others swing on a tree nearby and send more fruit tumbling down—one of which is being caught by a monkey lying on its back. Huge flowers like enormous hyacinths and water-lilies bloom amidst a forest of green leafy vegetation. Sometimes the changes of scale of flowers and animals, combined with the tendency for leaf forms to remain uniform in size (or even become larger) right up to the top of the pictures, in defiance of the laws of

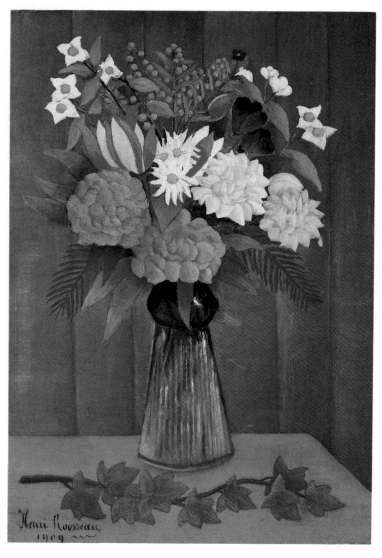

61. *Flowers in a Vase*. 1909. Canvas, 46 × 33 cm. (18⅛ × 13 in.) Buffalo, Albright-Knox Art Gallery

perspective, create the feeling of an irrational and dream-like world.

Robert Delaunay and Ardengo Soffici record that his practice when painting these jungle pictures was to begin by drawing in the main lines of the composition in charcoal. Then each colour was filled in following the outlines, one colour at a time; first, for example, all the greens, then all the reds, then all the blues and so on. Every area was painted direct and without retouching. He had such a clear idea in his mind of what the picture was going to be like that he could estimate how many days it would take him to finish it, and the only changes which he made in the course of its execution were the addition of a few further details which were always subordinated to the rhythm of the whole. He proudly drew Soffici's attention to the fact that he was using no less than twenty-two different greens, one after the other, for the picture on which he was then at work.

Though he was always in poverty (he could write to Apollinaire in 1909 that he only had 15 centimes for supper that evening) and was never much appreciated outside this small but very distinguished circle, he began to receive regular commissions and spent the last years of his life painting day and night, even sleeping in his clothes to save time. But unfortunately, when things were just beginning to go right for him, his happiness was marred by his rash involvement in a bank fraud and an unhappy love affair.

In the autumn of 1907 he was approached by a young man named Sauvaget, whom he had known some eight years before when they were both musicians in the orchestra of the *V<sup>e</sup> arrondissement*, and who told him that he had been defrauded by some bankers of all his money and asked Rousseau's help in recovering it. Following his instructions, Rousseau opened a bank account under a false name with money Sauvaget gave him

62. *View of Malakoff*. 1908. Canvas, 46 × 55 cm. (18⅛ × 21⅝ in.) Berne, Dr W. Hadorn Collection

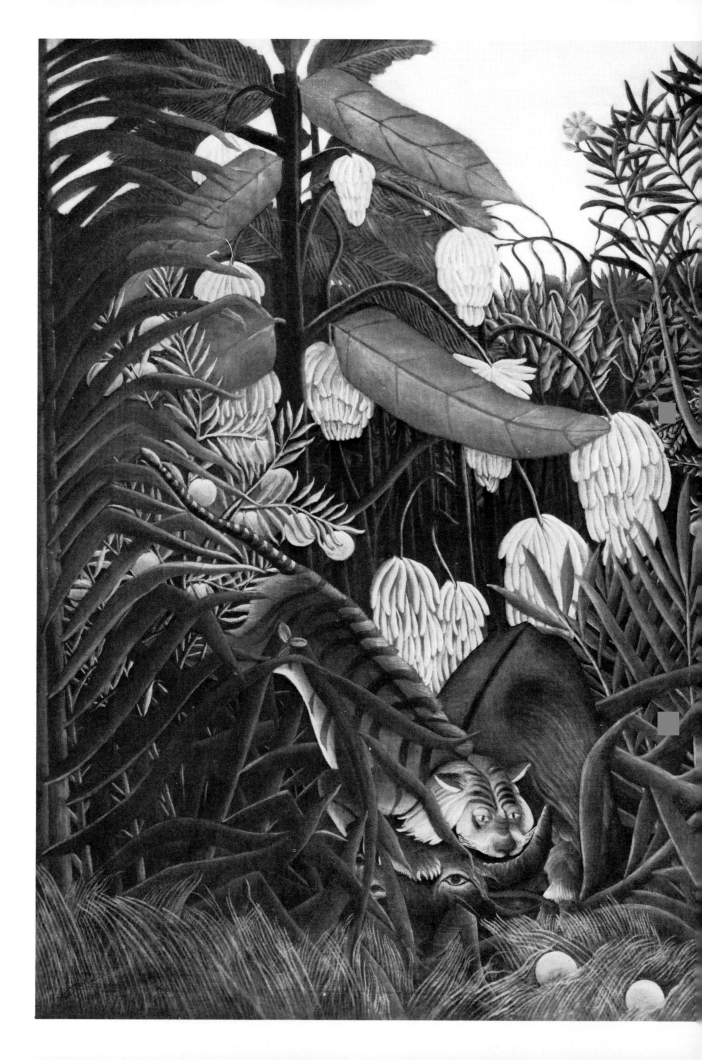

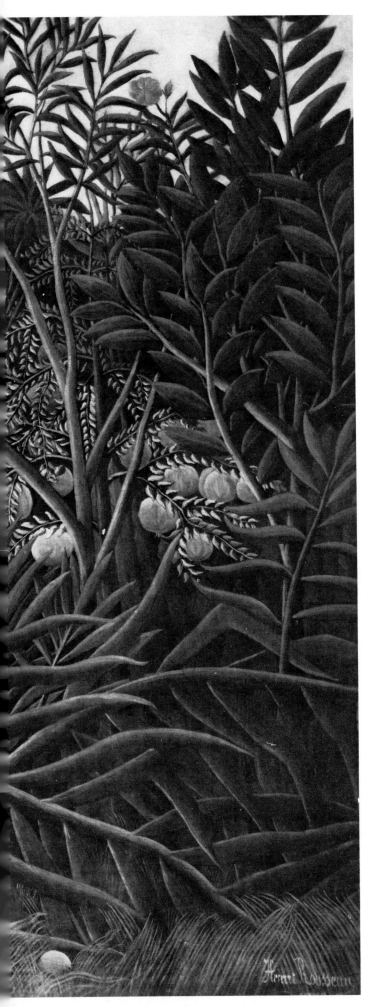

and obtained a cheque book. Then Sauvaget, who worked for the Banque de France and had access to official notepaper, forged a letter authorizing the branch at Meaux to pay 21,000 francs to a client of this name. The money was collected by Rousseau, who handed 20,000 francs to Sauvaget and kept 1,000 francs for himself, part of which he spent on tickets for a lottery in aid of tubercular children.

Rousseau's identity was soon discovered; he was arrested on 2 December and spent the rest of the month in prison. Bewildered to find himself in this position, realizing that he had been completely misled by Sauvaget, who had taken advantage of his credulity, he wrote letters to the judge from prison protesting his innocence. When the case finally came before the court on 9 January 1909, he appeared a grotesque and rather pathetic figure. There was laughter at everything he said; his press cuttings books, full of ridicule of his work, were produced in evidence; and one of his jungle pictures of monkeys eating oranges was shown to the court, causing great merriment. His counsel made an appeal for clemency ending:

> Also Rousseau is not completely disillusioned. This morning he said to me:
>
> 'If I am condemned, it will certainly be a bad thing for justice, but above all it will be a bad thing for art.'
>
> This man, he has been told, is a primitive. Do not condemn a primitive!

In the end he was fined 100 francs and given a suspended sentence of two years imprisonment, which meant that he was then released. Thus his naïvety, which had allowed him to be easily duped in the first place, helped to save him from a fate which might have been much

63. *Fight between a Tiger and a Buffalo*. 1908. Canvas, 172 × 191.5 cm. (67¾ × 75⅜ in.) Cleveland Museum of Art (Gift of Hanna Fund)

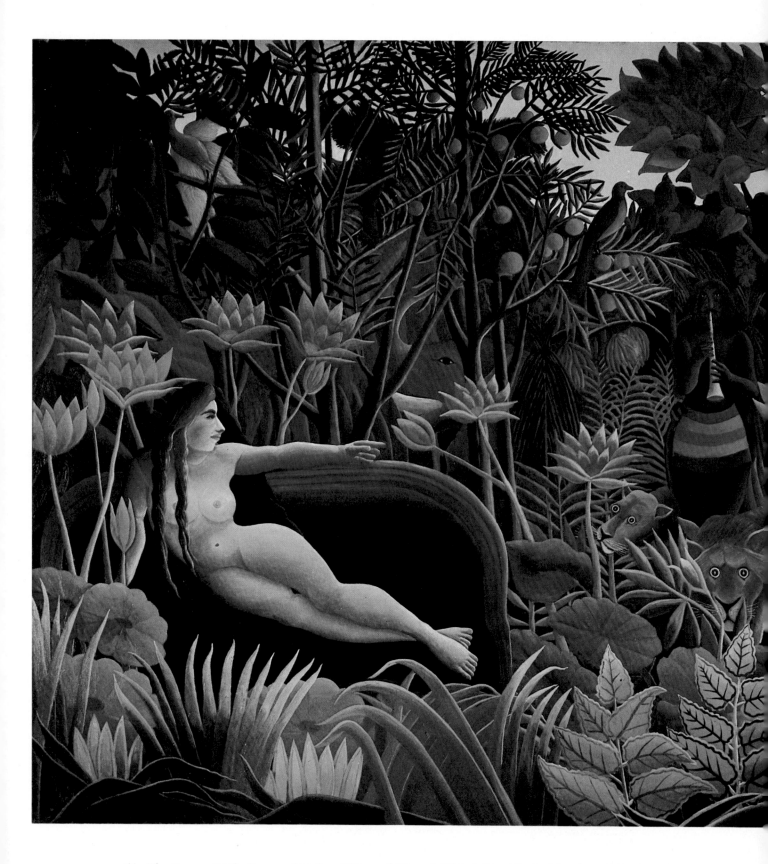

**64.** *The Dream.* 1910. Canvas, 204.5 × 299 cm. (79½ × 117¾ in.) New York, Museum of Modern Art

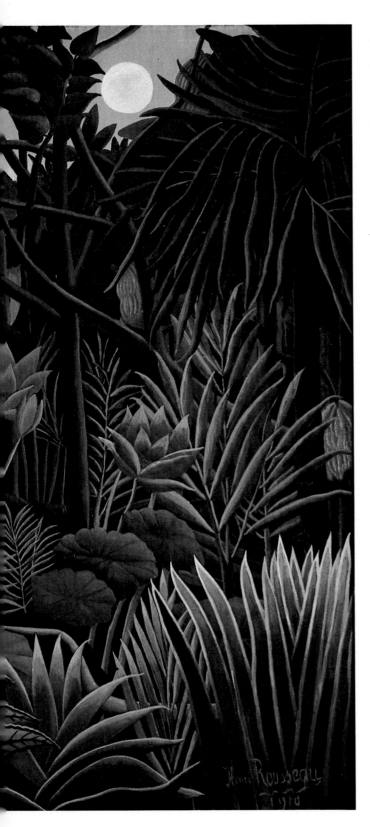

worse. Rousseau thanked the judge and told him: 'I shall paint the portrait of your wife.'

The other event which clouded the end of his life was an unhappy affair of the heart. Always in need of affection and strongly attracted physically to women, he fell in love with Léonie, the fifty-four-year-old daughter of one of his former colleagues in the octroi. She was indecisive and probably did not really care for him, while her father opposed the match on the grounds that Rousseau painted absurd pictures and had a police record. In despair, Rousseau begged Vollard, Apollinaire and other friends for certificates attesting to his talent and his honesty. He slaved at his painting to buy her expensive presents he could ill afford and wrote her a love letter only a few days before his death, but she did not even come to his funeral.

Rousseau's reawakened sensuality seems to have achieved sublimation in his last exhibited painting *The Dream* (Plate 64), which was shown at the Salon des Indépendants in 1910, accompanied by the following poem as commentary. (A poem which it seems on linguistic evidence may have been written for him by Apollinaire):

> *Yadwigha dans un beau rêve*
> *S'étant endormie doucement*
> *Entendait les sons d'une musette*
> *Dont jouait un charmeur bien pensant.*
> *Pendant que la lune reflète,*
> *Sur les fleurs, les arbres verdoyantes*
> *Les fauves serpents prêtent l'oreille*
> *Aux airs gais de l'instrument.*
>
> *Yadwigha in a beautiful dream,*
> *While sleeping peacefully,*
> *Heard the notes of a pipe*
> *Played by a friendly snake charmer.*
> *While the moonlight gleams*
> *On the flowers and verdant trees,*
> *The tawny snakes listen*
> *To the gay tunes of the instrument.*

As Rousseau explained in a letter to André

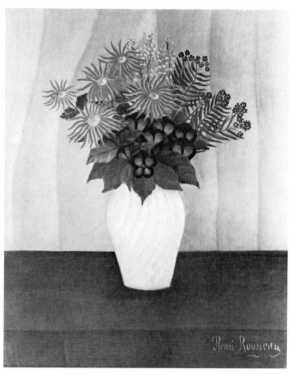

65. *Still-life*. 1910. Canvas, 38 × 46 cm. (15 × 18⅛ in.) Milan, Mattioli Collection

66. *Flowers*. About 1909–10. Canvas, 61 × 49.5 cm. (24 × 19½ in.) London, Tate Gallery

Dupont: 'The woman sleeping on the couch dreams that she is transported into the forest hearing the notes of the snake charmer's pipe. That is why the couch is in the picture.' And to André Salmon he added: 'Don't be astonished to find a couch in a virgin forest. It is only there for the richness of the red. You see, the couch is actually in a bedroom; the rest is Yadwigha's dream.' He told his friends that Yadwigha was a Polish school-mistress he had loved in his youth; there was also a character of this name in his play *The Vengeance of a Russian Orphan*. Naked, she points towards the snake charmer and the two rather bewildered-looking lions accompanying him, while all around the forest teems with exotic flowers and fruit, and with birds of paradise, monkeys and even an elephant lurking in the foliage. It is the evocation of a strange and fantastic world. Several days before the opening of the Salon, he wrote to Apollinaire: 'I have sent my large painting, everyone admires it, I hope you will use your literary talent to avenge me for all the insults and affronts I have received.' Thus we see a rare glimpse of how much pain these must have caused him.

Visiting Rousseau in August 1910, Uhde was alarmed to find him lying ill in bed, ghastly pale and with a painful sore on his leg. A few days later, he was taken to the Hôpital Necker, where he died on 2 September 1910 from gangrene of the leg brought on by sores and general neglect. His funeral on 4 September was attended by only seven people, because his artist friends were almost all out of Paris at that season and did not hear the news until it was too late, and he was

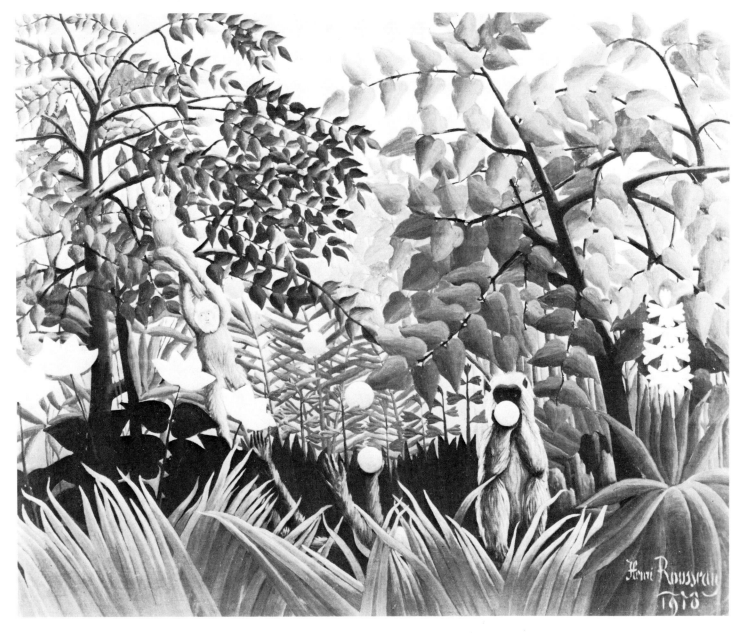

67. *Exotic Landscape*. 1910. Canvas, 130 × 162 cm. ($51\frac{1}{8}$ × $63\frac{3}{4}$ in.)
Los Angeles, Norton Simon Foundation (photograph Sotheby Parke Bernet Inc., New York)

buried as a pauper in a common grave. The works in his studio were afterwards sold amongst his friends to pay for his funeral expenses. However in March 1912 his body was re-interred at the expense of his landlord M. Quéval and of Robert Delaunay in a separate grave leased for a thirty-year period, and in the following year the tombstone was engraved by Brancusi and the painter Ortiz de Zarate with a poem written by Apollinaire in his memory. The Association des Amis de Rousseau purchased the grave outright in 1942, but in 1947 Rousseau's remains were transferred to Laval, his birthplace, and now lie there in a public park.

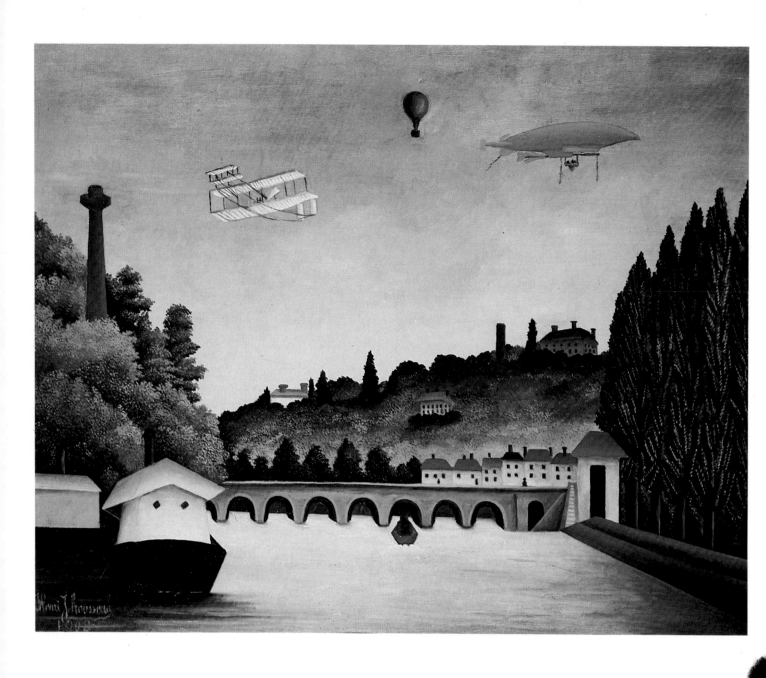

**68.** *View of the Pont de Sèvres.* 1908. Canvas, 81 × 100 cm. (31⅞ × 39⅜ in.) Moscow, Pushkin Museum